DIGITALPHOOORS

Martin has managed to cram a lot of information into a relatively small book . . . A great all-in-one reference (and an interesting read with some great photographs). You'll be well-equipped to start shooting better pictures and have a good handle on how to work smart in the field. —Digital Photographer

A must reference in this age of digital (photography) if you're shooting any outdoors subjects from sailfish to sunsets.

—Florida Today

If you want to improve your outdoors digital photography, this book will go a long way to help do that. *—Fort Collins Coloradan*

There's a wealth of practical advice in this book from an adventurer who has roamed the Earth's wild places in search of dramatic photographs and taught digital photography to countless amateurs while guiding photo safaris. *—Lexington Herald-Leader*

If a person takes (the) lessons (from *Digital Photography Outdoors*) into the field, odds are good he or she will come home with better shots.

-Boise Idaho Statesman

Digital cameras are in roughly 43 million homes, but few of those photographers are getting the most out of their high-tech gear. Digital Photographers Outdoors . . . is a new guide book that can help.

-Roanoke Times

What (Martin) learned will considerably shorten the learning curve for most of us. —*Reel News*

For those who like to jump into things with both feet, a copy of *Digital Photography Outdoors* might be in order. It goes beyond the basics of gee-whiz picture-taking, which makes it a bargain at \$16.95.

-Post-Standard (Syracuse, NY)

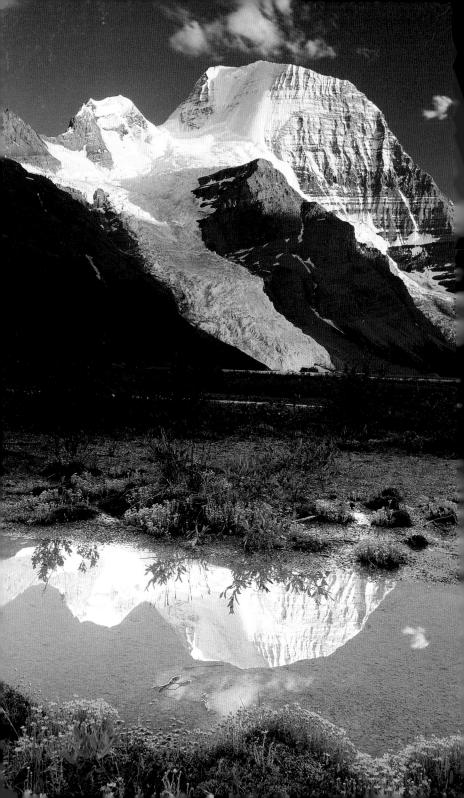

A Field Guide for Travel and Adventure Photographers

OUT DOORS

JAMES MARTIN

THE MOUNTAINEERS BOOKS

For Terrie

THE MOUNTAINEERS BOOKS

is the nonprofit publishing arm of The Mountaineers Club, an organization founded in 1906 and dedicated to the exploration, preservation, and enjoyment of outdoor and wilderness areas.

1001 SW Klickitat Way, Suite 201, Seattle, WA 98134

© 2004 by James Martin

All rights reserved. No part of this book may be reproduced in any form, or by any electronic, mechanical, or other means, without permission in writing from the publisher.

First printing 2004, second printing 2005, third printing 2006

Published simultaneously in Great Britain by Cordee, 3a DeMontfort Street, Leicester, England, LE1 7HD

Manufactured in China Project editor: Christine Clifton-Thornton Editor: Kris Fulsaas Cover, book design, and layout: Mayumi Thompson Photographer: James Martin

Cover photograph: Sunset at Kool Aid Lake, in the North Cascades Frontispiece: Mount Robson, British Columbia Back cover photograph: Mount Rainier

Library of Congress Cataloging-in-Publication Data Martin, James, 1950-Digital photography outdoors : a field guide for travel and adventure photographers / James Martin. p. cm. Includes bibliographical references and index. ISBN 0-89886-974-9 (pbk. : alk. paper) 1. Outdoor photography. 2. Photography—Digital techniques. I. Title. TR659.5.M27 2004 778.7'1-dc22

2004015889

Printed on recycled paper

CONTENTS

Foreword 7 Acknowledgments 8 Introduction 9

The Old Rules of Photography Still Apply 15

Composition 16 Light 28 Subject Color 37 Showing Up 39

Digital Equipment 42 Cameras 43 Lenses 49 Autofocus versus Manual Focus 55 Filters 55 Tripods and Heads 59 Photo-editing Programs and File Formats 60

Taking Digital Photographs 67

Old-school Exposure 68 Digital Exposure 72 Before Shooting 74 In the Field 79

The Digital Darkroom85Computer and Peripherals86Editing Programs88Color Management89

Work Flow 91 92

Advanced Techniques 113

Selections and Layers 114 Expanding Dynamic Range 115 Color Temperature Filters 118 Mimicking View Camera Movements 119 Black and White 122 Digital Panoramas 124 Digital Star Trails 128

A Digital Approach to Subjects 131 The Environment 132 Wildlife 144 People 147 Close-ups 150

> Glossary 151 Resources 155 Index 156

FOREWORD

I met Jim Martin during a busman's holiday Joe Van Os arranged for his Photo Safari trip leaders, a weekend of photographing captive hawks, eagles, and owls in Colorado. I was shooting medium-format film, which delivers much greater resolution and richness than 35mm slide film. Medium format demands patience and care. Motor drives, when they exist, are slow, and even changing film takes more time. I often lose photo opportunities, especially with wildlife photography, but the impact of a magical moment caught on medium format more than makes up for the trouble. Unlike the rest of the trip leaders, Jim also shot medium format, so I suspected I had encountered a sympathetic soul.

My suspicions proved correct. Jim also sought the highest possible quality and went to great lengths to attain it. At the time he was working on a photo book on the North Cascades Crest, carrying camping and climbing gear plus an assortment of medium-format camera equipment into high mountains. He crisscrossed trail-less terrain and camped on mountaintops over several summers to get the images he had in mind.

Over the years we traveled together to Africa and the Galapagos. When Jim visited my studio, I showed him my early work in Photoshop. I fed high-resolution scans into a computer before enhancing my photographs or creating fanciful images. (I think I can take credit for planting the notion of digital's potential in his mind in the early 1990s.)

On our trips, inevitably the conversation turned to photographic styles and techniques: improving image quality, innovative compositional styles, and the likely future of the medium. Both of us enjoy pushing the limits of our photographic vision, and our creative energy has always been stimulating and inspiring for each other.

In Digital Photography Outdoors I see that same passion for creating the best quality of image, both technically and artistically. This book reviews the essential precepts that digital and film photography share and then outlines the steps needed to draw the best out of digital while avoiding catastrophic errors. It's easy to send all those zeros and ones into the ozone with a misplaced keystroke, so heed the warnings scattered throughout the book. If you take his lessons to heart, not only will your photography improve but your files will be waiting for you where you left them, undamaged and properly catalogued. I consider the information contained in the following pages essential to getting the most out of your digital equipment as well as expanding your ability to create beautiful images.

—Jim Zuckerman

ACKNOWLEDGMENTS

I owe thanks to Scott Stulberg for reviewing the manuscript, keeping me abreast of the latest whiz-bang features in Photoshop and its attendant plug-ins, and, most of all, encouraging me to take the plunge into the digital ocean. Jim Zuckerman introduced me to digital editing at the dawn of Photoshop and opened my eyes to the possibilities. Without Art Wolfe's generous instruction, my photography would be weaker than it is and my storehouse of practical jokes and puns would be smaller. I reserve my greatest appreciation for my wife, Terrie, who puts up with a husband who spends an inordinate amount of time amusing himself—and even encourages him.

INTRODUCTION

When I was in high school, I used to hitchhike to Yosemite on weekends. I often saw Ansel Adams at work, unloading his car in front of Best Studios (now the Ansel Adams gallery) or leading workshops. I eavesdropped on the workshops, trying to pick up tips. He saw me lurking but only smiled. His explanations of the Zone system could have been in Phoenician for all the good they did me, but I could follow his comments on light and composition. I tried to apply his lessons when I shot photographs in the mountains, and his principles informed my shooting, but I had no patience for darkroom work. A small, dark cubicle was the last place I wanted to spend my time. Since black-and-white photography requires facility in the darkroom, I drifted into color photography.

Years later, a magazine assignment for the Smithsonian Institution sent me to Africa with Art Wolfe, one of the world's most prominent nature photographers. While we worked, he taught me the basics of his approach, and his instruction became the basis for my future shooting. Joining the crew at Joseph Van Os Photo Safaris brought me in contact with a diverse group of nature photographers, including John

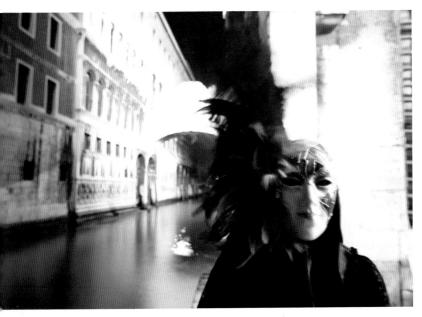

A woman wears a carnival mask in Venice, Italy.

INTRODUCTION

Shaw and Jim Zuckerman. While they agreed on the basics of photography, each employed a different way of seeing and working. Worldrenowned alpine climber Mark Twight introduced me to alternative films, processes, and perspectives.

GOING DIGITAL: THE EARLY YEARS

In the early 1990s, I visited Jim Zuckerman's office. He scanned his 6inch x 7-inch transparencies and then loaded these files into two Macintosh Quadra computers connected to a stack of hard drives. Any command took a long time to execute. Rotating an image, which takes a fraction of a second these days, consumed about a minute. The system frequently crashed. Jim possesses a large measure of patience and determination, evidenced by the large number of manipulated images he had created. I was intrigued, but the expense (his collection of electronics totaled tens of thousands of dollars) and laborious demands of using early versions of the Photoshop program put me off. Even so, the magic Jim had produced attracted me.

In the years since, Photoshop improved, computers became quicker and cheaper, and scanner prices fell. Low-resolution digital cameras appeared. The shape of the future was becoming clear. I bought a scanner so I could enter the digital world while I waited for digital cameras to improve sufficiently for professional work. I played with a Nikon "prosumer" model (a high-resolution point-and-shoot camera) to get acquainted with digital capture. When the Canon 1Ds digital camera body cracked the 30-megabyte barrier, I jumped in—and I haven't shot a frame of film since.

For years, professional outdoor photographers resisted the inevitable switch from film to digital. In addition to experiencing anxiety arising from the unfamiliar, they held back because digital couldn't deliver acceptable quality and performance. A lag between tripping the shutter and exposing the shot led to missed opportunities, which disqualified digital for shooting action. Long exposures in low light produced "noise," digital artifacts that looked like snow. Most important, digital images didn't equal the resolution the best slide films produced. But those days are over now.

THE DIGITAL REVOLUTION

The latest state-of-the-art digital cameras create images that surpass film in resolution, do not suffer from the grain found in film, and are not afflicted by excessive noise except on very long exposures. The delay between clicking the shutter button and capture is now shorter than that in the best film cameras. Even relatively inexpensive point-and-shoot

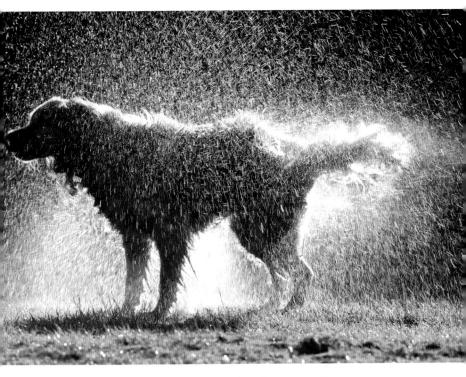

Backlighting highlights the water shaken from a wet dog.

digital cameras can equal their film equivalent in most areas and surpass them in others.

I believe we can work more efficiently and creatively with a digital camera. After shooting, we see the photograph on the spot and can correct mistakes immediately. Unconstrained by the cost of film, we are free to experiment with composition, filters, blurs, and exposure. Photography becomes more like play.

Some critics object to digital because they associate it with manipulation, but photographers have always manipulated film-based images to fashion their effects. A polarizer boosts saturation and removes glare present at the moment of exposure. Ansel Adams dodged and burned every print he ever made. Velvia and other dramatic films staples of the pros—generate heightened contrast and color saturation not found in nature. While these effects exist in digital, it is possible to create more tonally accurate images in digital than in film if desired.

Like any emerging technology, digital photography presents its own set of challenges and disadvantages. Storing images safely must become an obsession. Archiving pictures electronically is more time consuming than filing slide pages in a filing cabinet. A digital photographer must pay attention to batteries and chargers. Professionals spend more time preparing digital submissions, providing their agencies with varying file formats and sizes, printing thumbnails, and creating digital captions.

Still, digital photography's results trump its inconveniences. As photographers learn the freedom and control that digital photography affords, their ability to realize anything they can imagine soars.

HOW TO USE THIS BOOK

This book is intended for serious outdoor photographers, not necessarily professionals, but individuals who care about quality. In the pursuit of that end, we aim for maximum resolution, the widest range of color, and the largest file size with the least degradation over time. Thus, we relegate compressed file formats to the realm of snapshots, focusing our attention on the large file formats needed for high-quality large prints and for professional uses. In every case, we try to capture and retain the greatest amount of information.

It's impossible to make specific recommendations regarding computers and cameras. Both technologies are rapidly advancing, and the needs of each digital photographer evolve as competence and interest grow. I do cover the principal issues to consider before deciding on a given class of equipment, but I don't make specific recommendations because they would be obsolete by publication and wouldn't apply to many readers. Chapter 1, The Old Rules of Photography Still Apply, covers basics such as composition and light. Chapter 3, Taking Digital Photographs, compares old-school and digital approaches to exposure and offers steps to take before shooting and in the field. Chapter 2, Digital Equipment, and Chapter 4, The Digital Darkroom, add digital equipment to the discussion, including cameras, lenses, and filters, as well as file formats, computer equipment, photo-editing programs, and color management.

Chapter 5, Work Flow, presents a comprehensive description of a completely digital work flow. This includes imagining the end result, capturing the image, and bringing out its best form in the digital darkroom. Although photographing with film and scanning the result provides raw materials for the digital darkroom, the photographer ends up importing the deficiencies of film and missing the benefits of pure digital images. Therefore, this book ignores film photography and scanning except to compare the strengths and weaknesses of digital versus film photography.

There are various digital editing programs, as well as plenty of

excellent books about them. But, because Adobe Photoshop is the industry standard, I use Photoshop CS (the program's latest version) to illustrate step-by-step examples. Other programs have their own strengths and weaknesses, and just about any task a photographer would wish to perform in Photoshop can be accomplished in other editing programs or Adobe's own simplified version, Elements. Photoshop is a labyrinthine program offering multiple ways to solve any problem. In this book, I concentrate on the day-to-day enhancements every image requires; in Chapter 6, Advanced Techniques, I outline how to achieve useful effects without wandering into the surreal or the world of prepress.

Chapter 7, A Digital Approach to Subjects, offers insights into digital photography of certain types of subjects such as the environment, wildlife, people, and close-ups. The glossary at the back of the book defines terms; Resources provides information sources including books and Internet sites.

The information in this book should arm you with an understanding of how to create and store high-quality digital images that will look as fresh years from now as they do today.

Opposite: High winds roil sunset clouds in Patagonia.

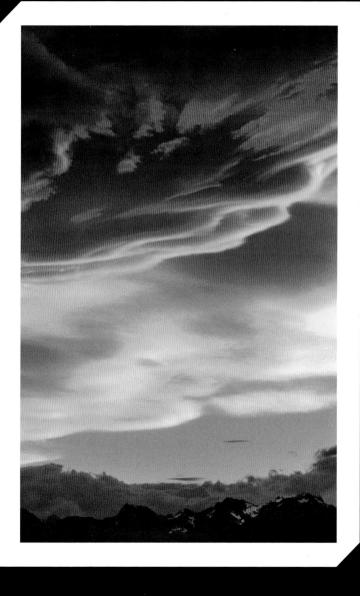

lthough digital photography opens new possibilities, the old rules of photography still apply. To get the best results, photographers need to pay attention to composition, light, and color.

COMPOSITION

The art of photography lives in composition. A great photograph is born in the eye and made tangible with the mind. The eye sees and the mind selects or imagines what could be. The juxtaposition of shape and space, the arrangement and movement of lines, the interplay of tone and color, and the angle and quality of light evoke emotional responses and elevate the resulting images from snapshot to composition.

Galen Rowell took his famous shot of a rainbow over the Potala Palace in Lhasa, Tibet, by recognizing that the elements of a great image were converging and then working to record what he imagined. He saw a rainbow some miles from the palace and knew it would bathe the palace in color if he could move to the right perspective. He set off on foot with a bag of cameras. He recognized that he was moving too slowly, so Galen stashed the cameras and ran a mile to the correct position with a single camera body and a few rolls of film. By the time he got to the best perspective, the rainbow had faded, but he waited in the gathering gloom for a burst of sun-driven color and was eventually rewarded with the shot he imagined: the Potala wrapped in tinted mist with a rainbow arching into the sky.

Composition can't be reduced to a set of rules such as the "Golden Mean" or the use of complementary colors. Dissonance has its place in photography as well as music. If we confined ourselves to major and minor scales, the blues wouldn't exist. Rules are tools, not laws.

Composition involves much more than arranging subjects in a frame. Color, tone, sharpness, and depth of field are involved as well. Imagine Picasso painting a version of "Whistler's Mother" (originally titled "Arrangement in Grey and Black"). Even if every element occupied the same space in the frame, no one would consider a Picasso version to be the same composition. Every element would be deconstructed and reassembled. Picasso's colors alone would overturn the original emotional impact. His style reflects an alternate universe.

Photographers can create the same kind of varying effects by composing in their imaginations and capturing that vision at the critical moment.

Scaling and Placing the Subject

Most good photographs have a center of interest anchoring the composition. The photographer must decide how to use the scale and placement of this subject—and surrounding elements—to create the desired impact.

Using the Rule of Thirds

Use the rule of thirds to draw the eye away from the center of the image. This avoids static or excessively unbalanced compositions and imparts dynamism.

Look for details in a grand scene. This shot of dead trees at Yellowstone's Mammoth Hot Springs works better than a bland, "descriptive" composition of the travertine terraces.

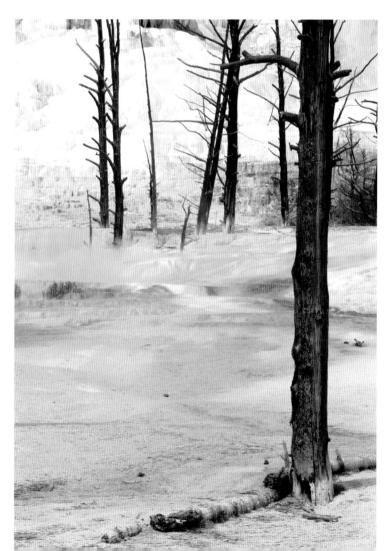

THE OLD RULES OF PHOTOGRAPHY STILL APPLY

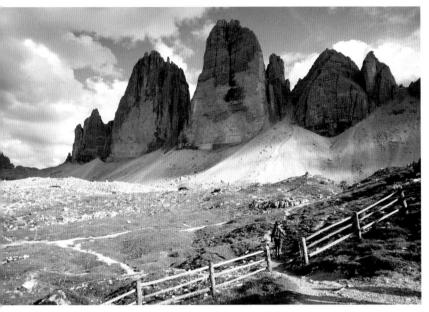

A human presence contributes scale to a photograph of Tre Cima, the three towers, in the Italian Dolomites.

First, imagine a grid of nine identical rectangles created by two horizontal lines and two vertical lines overlaying your image. Place your subject where grid lines intersect (there are four intersections). At the intersections, your subject will be about a third of the way toward a corner from the center of the image.

The rule of thirds can apply to multiple subjects in the same photograph or to strong lines such as trees or horizons. In most cases, a horizon passing through the center of a photograph produces a static composition. A dominating foreground or dominating sky occupying two-thirds of the frame combines balance and dynamism. The symmetry of splitting an image down the middle leaves the eye nothing to do.

The rule of thirds fails some subjects. For example, pattern and texture can be subjects in themselves. A close-up of a beehive emphasizes uniformity, and imposing structure on the image would blunt its impact. At other times, stasis is the point and symmetry contributes to the composition. A single eye centered in the frame can startle us.

Opposite: People add interest to travel photography. These young monks walking a trail in Bagan, Burma, also serve to balance the composition, which follows the rule of thirds.

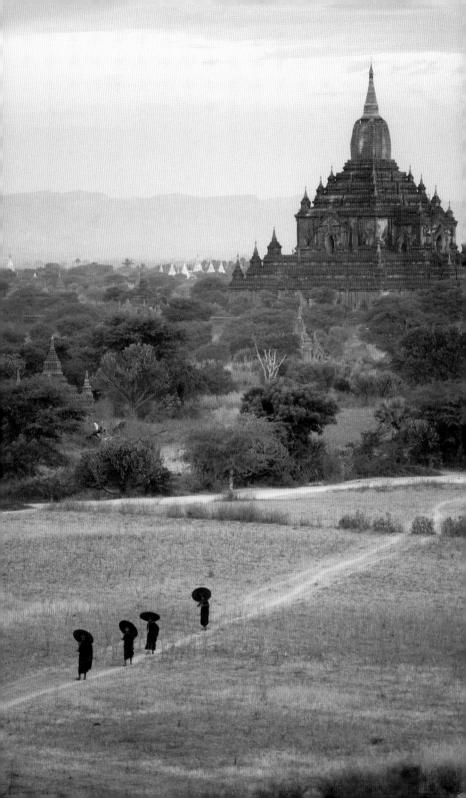

When pattern is the point, feel free to toss the rule of thirds.

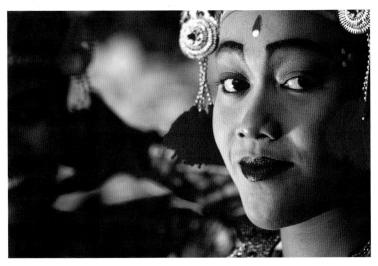

This composition demonstrates how the rule of thirds balances a photograph and how the eyes of the subject direct attention.

Directing Attention

Try to direct the eye of the viewer toward the main subjects.

When you photograph a subject such as a person or an animal, if the eyes of your subject are looking into the frame or directly at the camera, they will direct the attention of the viewer to the subject. This is usually

COMPOSITION

more effective than a subject looking out of the frame. A person standing to one side looking out of the frame directs attention away from the meat of the photograph. However, as with every rule, ignore this one when doing so bolsters the effect you seek. Such a composition can underscore a sense of solitude or alienation, which may be the point of the photograph.

Let the foreground lead the viewer's eye to the main subject or establish a point of reference to create depth. A lake or river in the

This Burmese tribe is famous for lengthening the necks of their women with heavy brass rings that depress the collarbone. Since the rings and the colorful scarves attracted my attention, I kept her eyes out of the composition.

foreground may lead toward a mountain in the background. When natural lines move from lower left to upper right (preferred in the West because we read in that direction) or from lower right to upper left, the sense of motion increases. An object in the foreground suggests depth by providing a sense of perspective.

Check to see if the background enhances or detracts from the image. Look for pleasing tones and colors. Moving a few feet to one side may make a big difference. Throw busy backgrounds out of focus with large apertures. In the same way, unwanted foreground details such as a stray branch distract the eye. Again, moving a few feet may remove the offending object from the frame.

TIP: GET HIGH OR DROP LOW

Photographers tend to shoot from comfortable positions, generally the height of a fully extended tripod. While this works for longlens photography, it rarely delivers the best results for shorter focal lengths. Discard habits of vision and find something new.

Looking down from the heights can reveal patterns. From an Olympian point of view, a herd of animals may become a sinuous line.

Try dropping low to include smaller objects in the foreground or to emphasize elements that only that perspective will deliver.

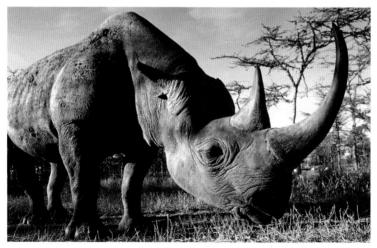

We don't expect to see wide-angle views of dangerous animals. This perspective emphasizes the mass of the rhinoceros by distorting its proportions.

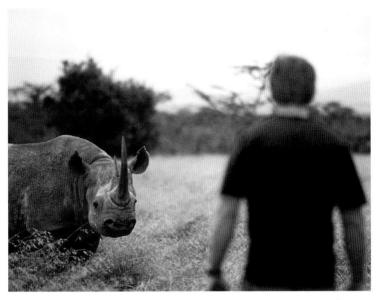

The impact of the picture changes by adding a person to the image of a dangerous animal. This rhino was raised by wardens in Kenya, so the risk was illusory.

Shooting Verticals

Beginning photographers tend to shoot exclusively horizontal images, but some subjects demand a vertical frame. Verticals allow you to focus on mountains, trees, waterfalls, and human faces, whereas a horizontal composition brings in more of the surrounding environment. Verticals provide room for interesting foregrounds. Choosing whether to shoot verticals or horizontals depends on what you wish to emphasize.

Aspiring professionals shoot verticals because they fit the page shape of most books and magazines. If you hope to sell an image for editorial or advertising use, shoot verticals and leave some blank space in the composition for text.

TIP: SAVE YOUR KNEES

Low-angle photography ravages the knees. Pebbles dig into the sensitive patella tendon, and disability eventually will result. Carry a small square of closed-cell foam to cushion your knees, or buy the foam-and-plastic knee pads roofers wear.

THE OLD RULES OF PHOTOGRAPHY STILL APPLY

Using Sharpness versus Blurs and Motion

The sharpness of an image is a function of (1) lens quality (see Lenses in Chapter 2, Digital Equipment), (2) depth of field (see the next section), and (3) shutter speed (see Old-school Exposure in Chapter 3, Taking Digital Photographs) in relation to the movement of the subject. First, the very best lenses are sharp from corner to corner at any aperture. Zoom lenses tend to be a little soft in the corners and at the largest apertures. For maximal sharpness, stop down one or two f-stops from the fastest setting. Second, if your camera has a depthof-field preview button, use it to confirm that the important elements are in focus. Third, use a fast enough shutter speed to freeze a moving subject if that is your intention.

Photographers can convey movement by blurring the subject. For example, falling water looks crystalline if shot at a fast shutter speed. Letting water blur a little restores the impression of movement. Deliberate blurring of flying birds or running animals generates the same impression.

The portrait of a tiger (shown in this section) looks nice and sharp,

Keep the eyes sharp in tight face shots.

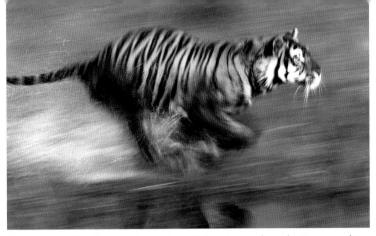

Focusing on the tiger and panning while using a slow shutter speed to blur both tiger and background creates a sense of speed and power.

but the blurred version creates dramatic movement and produces a pleasing impressionistic effect. To blur the tiger, I reduced the shutter speed and panned to keep the subject almost immobile in the viewfinder. In this example, I shot the tiger at 1/30 second.

The ideal shutter speed is a function of the speed of the animal, the length of the lens, and your distance from the subject. Experiment to find the right relationship for any given situation. This is a snap with digital cameras because of the instant feedback they afford. Digital cameras record aperture and shutter speed for each shot. When editing your photos, check the Metadata (a complete record of exposure information found in Photoshop and other programs) for the shots that worked best to learn which shutter speed yields the best result for a given

A good animal portrait is usually pretty but static.

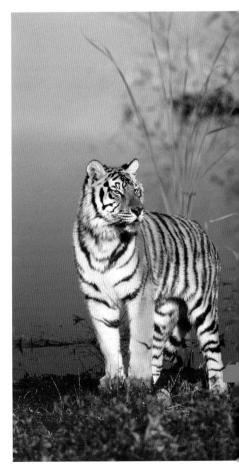

lens length and subject distance. When shooting with film, record the shutter speed used for each exposure in the field until the relationships are fixed in your mind.

Using Depth of Field

Each composition requires a specific depth of field: the range of focus.

A very shallow depth of field isolates and emphasizes one element in a composition. In a portrait of a person or animal, a busy background distracts attention. Opening up the aperture collapses the depth of field, blurring the background and focusing attention on the subject. Look for opportunities to truncate depth of field. A single sharp flower set in a wash of color created by a field of out-of-focus flowers directs the eye to the desired subject.

I achieved adequate depth of field by stopping the aperture down to fI32 and focusing midway down the stamen.

COMPOSITION

A landscape that needs sharp focus from foreground flowers to distant mountains requires a small aperture setting such as f/16 or f/22. Smaller f-stops keep the background sharp even when the primary focus point is not set on infinity. The point of maximal focus that creates the greatest depth of field from infinity to foreground is called *hyperfocal distance*. Some lenses have markings to indicate where a hyperfocal focus point is for each major f-stop, and charts are available for manual settings.

Depth of field varies with lens length. A wide-angle lens captures more depth of field at any given f-stop than does a long telephoto lens. Depth of field is fixed for that focal length without regard to the format of the camera in use. A 100mm lens at f/8 will provide the same depth of field whether used on a 35mm point-and-shoot or a 4x5 view camera, even though the angle of view changes dramatically.

Most professional cameras feature a depth-of-field preview button near the lens. When you focus, the lens automatically defaults to the widest aperture, letting the maximum available light reach the eye for easy focusing. When you press the depth-of-field preview button, the lens manually stops down to the actual aperture setting. This reveals the depth of field seen at the film plane. However, very small settings pass scant light to the viewfinder, so determining depth of field visually is sometimes difficult. To determine the range of focus, wait a few moments for your eyes to adjust to the darker image.

A rough guide to depth of field is the one-third/two-thirds rule. It states that, for any given f-stop, the depth of field expands twice as far behind the point of maximum focus as in front of it. For example, if you focus on a boulder 30 feet away and the picture looks in focus 10 feet in front of the boulder, the picture will be in focus 20 feet behind the boulder as well. You can eyeball this effect with the depth-of-field preview button; or rely on it when things are moving too fast to allow you to calculate, and the lens lacks a depth-of-field scale.

TIP: THE ONE-THIRD/TWO-THIRDS RULE

If you don't have time to calculate depth of field, focus just in front of the main subject. The one-third/two-thirds rule suggests the critical part of the image will be in focus. This is less likely to work when you are close focusing because the one-third/twothirds rule collapses to 50/50 in such cases.

• 27 •

Lens Length	f/8	f/11	f/16	f/22
16mm	3.5 feet	2.55 feet	1.75 feet	1.27 feet
20mm	5.47 feet	3.98 feet	2.73 feet	1.99 feet
35mm	16.75 feet	12.18 feet	8.37 feet	6.09 feet
50mm	34.18 feet	24.85 feet	17.09 feet	12.43 feet

LIGHT

When Art Wolfe and I visited Tanzania, we hired a van with a pop-up top and a driver. Art generously imparted his thinking while he worked and let me look though his viewfinder so I could see examples of what he was talking about. Watching him create a composition was revelatory. He infuriated our driver by repeatedly instructing him to move a few inches forward or back to eliminate distracting backgrounds or foregrounds as a tiny flycatcher flitted among the reeds. He preached simplicity, balance, and powerful perspective, but his sensitivity to the quality of light and color impressed me most. Without the right light, the other elements of composition couldn't bring an image to life.

I remember my first close-up lion. Our van parked 15 feet from a big male. He lay in tall grass under the noon sun, eyes staring at me. I set up with excitement; the lion's face filled the frame. I metered, focused, and looked behind me. Art stood with his arms folded, shook his head no, and explained the light was too hard. I took the picture anyway, but when I got back to the digital darkroom, I understood what he meant. Contrasting highlights and shadows robbed the image of color, and shadow masked the lion's eyes, the heart of the photograph.

Over the course of the next few weeks, I photographed dozens of lions in different light, and each angle and quality of light produced a different effect.

The Direction of Light

The quality and effect of light vary with its direction and intensity.

Front light. When the sun is behind you, few shadows appear on the subject. This is front light. The closer the light source is to the horizon, the fewer the shadows. Although front lighting delivers a lot of detail, it sacrifices drama and three-dimensionality.

Side light. Especially with a low-angled light source, side light adds drama. Shadows on one side create depth and isolate the most

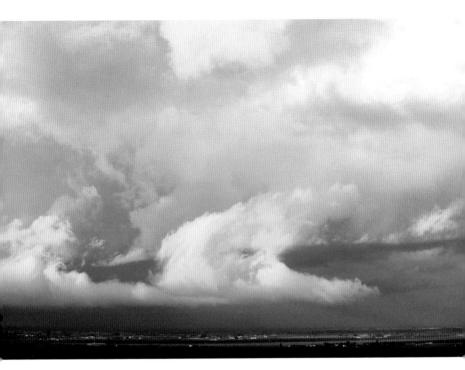

I drove up the Central Valley of California in unsettled weather, desperately looking for a subject to suit the light. Just before the sun set behind me, it lit the foreground, which added the compositional anchor the clouds needed.

important elements of the subject. For example, an animal in profile facing the setting sun will have eyes that gleam compared with the shadowed back of its head.

Backlight. This creates bold shapes. A deer in silhouette at sunset will be fringed by a penumbra of golden light. Placing a backlit subject against a dark background amplifies the effect. Fill light from a reflector or flash adds detail to the subject without obliterating its outline.

Indirect light. For some subjects, nothing beats indirect light. Studio photographers avoid the harsh direct light of a single flash by diffusing light, either by sending it through a translucent membrane (soft box) or by bouncing it off a large reflective umbrella. These techniques banish unwanted shadows, and we experience the reduced contrast as soft light.

Outdoors, indirect light can be diffused by overcast or fog, which acts as an immense soft box. This allows midtone colors to pop. You

Backlighting transformed this action image taken at Lake Louise Falls into a strong graphic statement.

can shoot wildlife or forests from dawn to dusk on a persistently overcast day.

Art Wolfe and I got up early one drizzly morning in Samburu National Park in Kenya. Trees buzzed with iridescent bee-eaters, ostriches patrolled the brush, and reticulated giraffes nibbled on leaves. The rain abated, but thin cloud still muted the sun. The colors glowed with supernatural richness.

At 10 $_{\rm AM}$, we were about to shoot a small group of waterbucks, but the sun burned through the mist. Art mumbled a few choice phrases

Backlighting highlights the shapes of falling water at Yosemite Falls.

and told the driver to take us back to camp. The equatorial sun had leached the color out of the scene. We knew we would toss the results of any further shooting.

Outdoors, you can also look for natural reflectors to capture indirect light. In canyon country, light bounces off colored walls and illuminates subjects in shadow. A snowy hill or brightly lit lake reflects light equally well.

The Color of Light

The color temperature of light affects an image as much as the direction of the light does. Color temperature is defined as the color that a black body (imagine a lump of black metal) would radiate at any given temperature in the Kelvin scale. Kelvin begins at absolute zero, -459.67° Fahrenheit, and uses the same increments as the Celsius scale. When the black body first reaches a temperature that emits visible light, it glows dull red, hence the term *red-hot*. As the temperature rises, the color changes, first yellow, then white, and then blue, until it winks out of the visible spectrum as it passes into ultraviolet. Note that we consider oranges and reds warm colors and think of blue as cool, but in the world of physics, the opposite is true. We experience 5500° K, the color temperature of light at high noon, as neutral white light. Different light sources have different color temperatures.

Color temperature changes with atmospheric conditions, the quality of reflective surfaces, and the time of day. Film manufacturers designed specific films to record white accurately for various color temperatures. When planning a shoot, try to recognize how changing color temperature will affect the color of your resulting photograph so you can select the most appropriate film, white balance setting, or filters to compensate.

Daylight. This corresponds to around 5500° K. Daylight film is calibrated to deliver accurate tones in daylight after the warmth of sunrise light cools and before sunset tones appear.

Open shade. This ranges from 7000° to 9000° K. The dome of blue sky above colors the light. When shot in open shade on a sunny day, daylight-balanced film or a digital camera set to the Daylight White Balance records a blue cast. Daylight films require the use of a warming filter to restore neutral color. Setting White Balance to Shade accomplishes the same thing digitally. Sometimes the blue cast enhances a composition. A blue hue contributes to the impression of cold in a photograph of a shaded frozen waterfall.

Opposite: A gold reflector bounced sunlight on this Mandalay woman's face.

Confronted with dull overcast, I breathed on the lens to mimic fog and later used the computer to add an orange cast.

Clouds and haze diminish the blue effect, and when they block the blue sky completely, the blue cast disappears.

Overcast. An overcast sky ranges from 6000° to 7500° K, a slight tilt to the blue side of the spectrum as seen by a daylight film. Generally, there's no need to compensate for the shift in color temperature.

Sunrise and sunset. When the sun is near the horizon, its light refracts as it passes sideways through the earth's moist and dusty atmosphere. The refraction shifts color and endows a scene with rich warm

tones, 2000° to 3000° K. Photographs benefit from the added warmth, combined with a pleasing effect of low-angle light, hence the term *magic light*.

Twilight. Some of the best light is found about a half-hour before dawn and a half-hour after sunset, when the light of the sun barely illuminates the sky. This corresponds to about 12,000° K. You can see a boundary where a faint pinkish tone meets the dark blue of night. When that pinkish tone falls upon a landscape, the subjects glow faintly against a dark background, an interplay of colors worth capturing.

Artificial light. When we photograph a city at twilight, the streetlights, neon signs, and buildings glow with different color temperatures. An ordinary incandescent lightbulb shines at about 3000° K; its light looks yellow to daylight film. Mercury vapor lamps emit

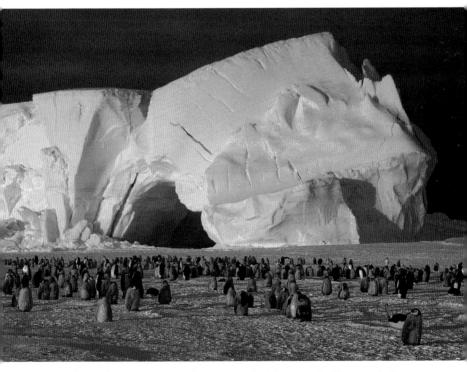

A colony of Emperor penguins surrounds this grounded iceberg in the Weddell Sea in Antarctica. Although polar regions enjoy magic light for hours at a time, this day the sun burned through the thick fog for only a few minutes.

THE OLD RULES OF PHOTOGRAPHY STILL APPLY

Dissipating fog momentarily refracts the rising sun.

a greenish light. Because there's no single color temperature in the scene, there is no absolutely correct White Balance setting. Set the camera to Auto White Balance for the most neutral results, but don't be afraid to experiment with other color temperatures to create different effects.

Degrees Kelvin	Light Source	Color of Light	
1900	Candle	Red	
2000–3000	Sunrise and sunset	Orange	
3000	Incandescent lightbulb	Yellow	
5500	Daylight	White	
6000–7500	Overcast	Light blue	
7000-9000	Open shade	Blue	

SUBJECT COLOR

People respond to color photographs. Although black-and-white images have their own power, color taps into our emotions. We react to the tint, hue, and saturation of individual colors and the relationship between colors. An image composed of vivid primary colors triggers a reaction different from what an identical picture composed of pastels triggers, and the juxtaposition of complementary colors triggers a reaction that differs from what harmonious colors trigger. When you become aware of the quality of colors and their relationships, you can select a composition that takes advantage of their attributes.

Complementary Colors

Complementary colors consist of a primary color and the secondary color opposite it on a color wheel. The primary colors are blue, red, and yellow; secondary colors, derived from mixing two primary colors, are green, purple, and orange. When set against each other, complementary colors appear especially rich and dramatic. Artists use complementary colors to create impact. For example, the red berries of a green holly bush or green trees standing next to the red rock of the Southwest seem to leap out of the frame.

Look for complementary colors when shooting flowers.

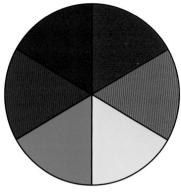

Harmonious Colors

Neighboring colors on the color wheel are called harmonious colors. They have similar hues and produce a pleasing and more muted effect than complementary colors. Sunset clouds fall into this category when we see reds, yellows, and oranges interlaced in the image.

Desaturated Colors

Whereas bold colors demand attention and create drama, desaturated

colors such as pastels invoke a gentle impression. Sometimes these colors are inherent in the subjects, such as a field of flowers or a fading sunset, and sometimes atmospheric conditions such as haze or smoke leach vividness out of the original colors.

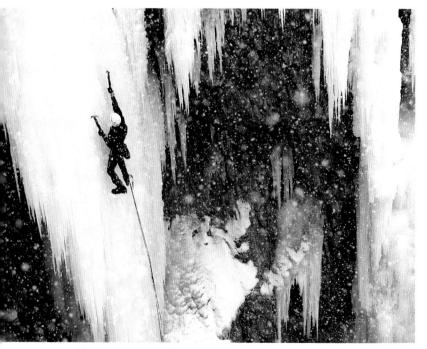

A mild snowstorm transformed this shot, taken in Ourey, Colorado, from ordinary to atmospheric.

Color wheel

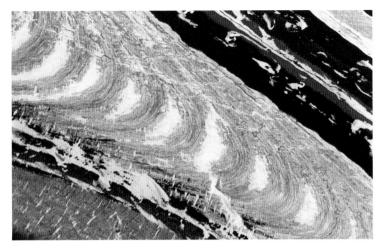

Medial moraines of Denali's Kahiltna Glacier create a natural abstract.

Homogeneous Colors

A scene consisting of variations of a single hue is the color equivalent of black and white. The drama of color is removed, leaving the opportunity to emphasize shape, line, and texture. A forest of Douglas fir becomes a pattern of vertical lines without a center. Snowy hills with the sky cropped out become an exercise in pure form.

SHOWING UP

People say 90 percent of life consists of showing up; hence, the photographer's dictum "f/8 and be there." In other words, a photographer must anticipate where photographic opportunities will appear and then show up at the right time. Many of my best images required neither intellectual effort nor artistic talent. The composition was irresistible, and a baboon could not have missed it. In such situations, if the light cooperates, you are almost forced to photograph it.

Luck is the residue of design. Plan your days so you can be in position when the light takes a turn for the good. Scout for good positions when the light is mediocre. This discipline invites serendipitous moments.

When I first considered becoming a professional photographer, I went to Africa with Art Wolfe. Although we had a good time, there was no doubt this was a serious enterprise. Every day we rose before dawn, photographed for several hours, ate and rested, scouted for a good position for sunset and the following sunrise, and then set up for the sunset shots. The universe rewarded us for our efforts. At the end of a rainy afternoon at Lake Manyara in Tanzania, a double rainbow formed

After days of rain, a sliver of light illuminates the Alaska Range.

at sunset over a line of buffalo, with hippopotamuses in the foreground glowing in the golden light.

Jack LaLanne once said that some days he would rather take a beating than get up for a workout, and I often feel the same way about sunrise shots. I learned never to give up on the light. In the Serengeti, heavy rains swept the savanna just before sunset. Art continued to look for opportunities. He noticed a group of zebras huddled together as the downpour pounded us. He whipped out a long lens and captured an atmospheric image of the zebras seemingly shrouded in smoke.

I made the mistake once of giving up on Easter Island. Toward the end of the day, I saw a wall of gunmetal gray cloud approaching. The sun was an hour from setting and I was certain I wouldn't see it again, so I drove into town for dinner. As I waited to be served, I noticed from the little restaurant that the light was turning pink. I ran outside and was confronted by a horizon-to-horizon Technicolor spectacular. With just a little patience, I would have photographed the tall stone *moi* silhouetted against an improbably vivid sky. As it was, I missed the best shot of the trip.

These days, I wait to the bitter end. Although I often go home empty-handed, when the sun cooperates, slashing under the cloud cover for a moment and infusing the scene with color, I take some of my best images.

Opposite: Low light, blooming trees, and an accommodating model made for an effective portrait.

Digital Equipment

2

igital technology doesn't overthrow the eternal verities of photography. The tasks needed to capture an image differ little between film and digital. The rules of composition still apply, the precepts of exposure diverge only slightly, and filters generate identical effects. But digital technology

removes constraints that once blocked the realization of photographers' visions. Although digital photography calls for a new set of habits for efficient work flow, the largest change is conceptual.

A digitally captured image represents the first step of a work in progress. But even before shooting, a digital photographer may imagine how the image will change as it passes through an editing program en route to the final product, whether a print or an archival file. A pretty scene may gain drama if converted to a high-contrast black and white or it may cry out to become a panorama. Although we can make such decisions after shooting, imagining a final result and taking the steps to realize it are the crucial steps toward mastery.

Learn the basics step by step (see Chapter 3, Taking Digital Photographs). Establish a repeatable and efficient work flow (see Chapter 5, Work Flow). Experiment to learn the range and limits of digital exposure. Master color and contrast optimization. Acquire the special techniques needed to replicate classic films and effects (see Chapter 6, Advanced Techniques), the punchy saturation of modern slide films or old low-contrast sepias, the sweep of a panorama, or the depth and perspective of a view camera. Once these techniques are firmly in your grasp, wander into the surreal if you wish.

This chapter reviews the different types of digital cameras, as well as other equipment used in digital photography. The effective focal length of lenses changes according to digital sensor size, but the qualities needed in a lens are the same for digital photography as for film. Filters behave the same in both film and digital photography. Tripods remain a necessary evil in both worlds. As always, vision, imagination, and craftsmanship count for more than equipment quality.

Although this is a book on digital photography, computer image editing inescapably comprises a large portion of the text. Hence, among the digital "equipment" you need to get started is a photo-editing computer program (and a computer to run it). Much of the power of working digitally is found in programs such as Adobe Photoshop CS, its myriad competitors, and add-on plug-ins. In this chapter, I review the essentials and allude to other capabilities. The basics—color correction and filing—are easy to learn, but facility with all the tools available requires a steep learning curve that includes topics beyond the purview of this book.

CAMERAS

The quality of a film camera is almost irrelevant. A brand's entry-level camera body and its top-of-the-line body will both produce an identical image when using the same film and lens. In a film camera, film acts as a sensor. Camera bodies differ primarily in ruggedness and features. Some features, such as the speed of the motor drive or quick autofocus, affect performance in the field, but most of the time there is no difference in performance. However, with digital cameras, the size and resolution of the digital sensor, combined with the speed and sophistication of the signal processing, determine the quality of the final image and ease of use.

Camera Basics

Getting professional-quality results with digital cameras demands a significant outlay. A professional digital camera body costs thousands of dollars, and the memory cards and storage needed to preserve files can add thousands more. An entry-level digital camera, on the other hand, costs little more than a film camera and saves the recurring costs of film.

A professional can recoup the cost of switching to digital after a few assignments, from savings in film cost alone. On an African safari, it's not uncommon to shoot 20 or 30 rolls a day. A month-long trip could have 20 shooting days or more. This translates to a minimum of 400 rolls of film. The cost of the film and processing would total more than \$4000. After a few such trips, a professional photographer who switches to digital will be in the black, with the savings going directly to the bottom line.

The number of pixels (short for picture elements) the digital sensor can capture constitutes one measure of digital performance. The more pixels, the greater the resolution. This can be expressed two ways, either as the number of pixels available in the sensor or as the uncompressed file size (more on this in the next section). The Canon 1Ds is an 11 megapixel (11 million pixel) camera that yields a 30megabyte 8-bit TIFF file (after RAW processing; see the next section).

Unfortunately, file size doesn't tell the whole story. Sometimes a lower-resolution camera produces a more pleasing and accurate result than a higher-resolution camera. The quality of the camera's signal processing electronics accounts for the variation. The innards of digital cameras generate "noise" (a kind of digital grain) and other digital artifacts while doing a better or worse job of interpreting color. Checking the file size specification of the digital sensor is a good first step when shopping for a digital camera, but the only way to tell how well it works is to take test shots if possible. To test cameras, take a memory card to a camera store. While you are there, shoot the full range of tonal values. A midtone such as green grass or blue sky will give a good idea of color accuracy. Shoot dark shadows. Lesser cameras often produce noticeable "noise" in deep shadow. A very bright subject may overwhelm the digital sensor so that no detail appears. Then take the card home, download it on your computer, and blow the image up to at least 100 percent. This will reveal digital noise, pixelation, and unevenness of color if these exist. If the file quality meets your standards, the camera is a candidate for purchase, and you can make your decision based on features, feel, and price.

Sensor size. A full-sized sensor has the same dimensions as a 35mm slide and equivalent magnification for any given focal length lens. At this writing, only a couple of cameras offer full-sized sensors. Smaller sensors add magnification. Professional models add 30 percent magnification; consumer cameras add 50 percent to 60 percent.

Although sensor-induced magnification increases the reach of a telephoto—a 300mm lens may have the same angle of view that a 390mm lens would have with a full-sized sensor—wide-angle lenses become less wide. On a professional camera, a 28mm wide-angle lens becomes a 36mm—a big difference—and on a consumer camera, the 28mm becomes an effective 44mm, hardly wide angle at all. Additional magnification allows wildlife shooters or birders to capture tight shots without spending the money and carrying the weight of longer telephoto lenses, but landscape photographers will miss the wide-angle view.

Viewfinder versus screen. Single-lens reflex (SLR) cameras bounce light from the lens to the viewfinder with a mirror. The photographer sees what the lens sees. Most consumer digital cameras use viewfinders. A viewfinder camera can produce an equally good photograph, but focus can be confirmed only by checking the camera's LCD screen after exposure. These screens are often too small to verify focus, although they work well enough for double-checking exposure.

TIP: MAGNIFY THE LCD SCREEN

For a better view of the LCD screen, carry a 4x loupe, a small magnifying glass designed for editing slides. Placing it over the camera screen blocks outside light so glare doesn't obscure the image. Because the screen is composed of small dots in a field of black, sharpness remains tough to determine. Wrap the edges with gaffer's or electrical tape where the loupe meets the screen to prevent scratching. (Thanks to Scott Stulberg for this tip.)

The light meter in an SLR camera reads the light after it passes through the lens and any filters, but digital viewfinder cameras often place the light meter on the body of the camera; this means it won't compensate for changes in exposure caused by added filters. When using a polarizer or a graduated neutral-density filter in situations where calculating the exact filter factor is difficult, hold the filter in front of the light meter on the camera body. I prefer to use manual exposure in such situations so the camera doesn't change exposure after I move the filter from the light meter to the lens.

Camera Types

Digital cameras fall into four basic categories: consumer, "prosumer," professional SLR, and professional SLR with a full-sized sensor.

Consumer. These are light, inexpensive, and relatively low-resolution. They feature built-in (fixed) lenses, usually zooms. These qualities match what most people want in a camera, and such cameras

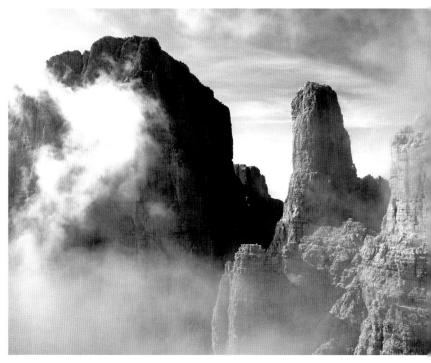

I carried a lightweight prosumer camera on a via ferratta traverse of the Italian Dolomites where a pro body and lenses would have been too bulky and heavy to carry.

yield acceptable results for snapshots and smaller prints.

Less-expensive cameras suffer from shutter lag, the delay between tripping the shutter and actual exposure. All consumer digital cameras employ small sensors. Because small sensors create a telephoto effect, none of these cameras possess true wide-angle capability. Limited imageprocessing capability means these cameras must stop to process data after each shot, especially when set to generate larger file sizes that fill the camera's memory buffer. Consumer cameras don't have through-the-lens (TTL) capability. In other words, when you look through the viewfinder, you only frame your image—you can't determine focus without looking at the LCD screen. The resolution of the LCD screen is poor, so focusing becomes a matter of faith. Finally, consumer cameras usually place the light meter on the body instead of behind the lens; this invites small errors when measuring exposure.

Since most of these deficiencies relate to speed in shooting, a beginner can learn the elements of digital photography with a consumer camera. The basics of exposure, composition, file transfer, and image optimization still apply.

Prosumer. These cameras bridge the gap between consumer point-and-shoots and professional bodies—hence the term *prosumer*. They feature higher resolutions and higher-quality lenses, but they still lack the flexibility and resolution of professional models. However, resolution is good enough for some professional uses, especially if you stitch several shots together to create a panorama or wide-angle effect, which swells file size and, thus, effective resolution. Although shutter lag doesn't plague prosumer cameras, users still experience processing delays and the telephoto effect of small sensors. The difficulties inherent in non-TTL cameras apply to prosumer cameras as well.

TIP: USE ACCESSORY LENSES TO EXTEND FIXED LENSES

Many consumer and prosumer cameras accept accessory lenses to extend the range of their fixed lenses. These lenses convert the standard lenses to wide angles, macros, and telephotos. Even the highest-quality add-on accessory lenses degrade sharpness somewhat, but the added capabilities are worth the small sacrifice.

Professional SLR. These digital cameras don't experience shutter lag. Processing delays don't bog down such cameras unless a motordrive burst fills the buffer. These cameras still employ small sensors, a problem for photographers who like to shoot with very wide lenses.

• 46 •

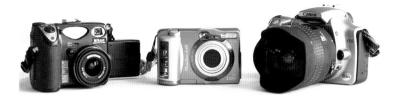

Cameras, left to right: prosumer, consumer, digital SLR

Wildlife and sports photographers can save thousands of dollars on telephoto lenses because the additional 30-percent magnification costs nothing extra, which compares favorably with long, fast lenses that cost thousands of dollars. This class of digital camera has become a favorite among sports photographers because it captures sufficient resolution for magazine use while the file size of its images don't overwhelm the buffer, allowing the photographer to take many shots before the camera shuts down to process data.

Professional digital SLRs are TTL cameras with all the advantages that implies. It's easy to confirm focus, and the light meter is stationed behind the lens, which means the meter compensates for filter factor automatically.

Professional SLR with full-size sensor. This type of digital camera recently hit the market. It possesses all the advantages of professional SLRs and features the highest-resolution bodies available in the digital 35mm format. Shutter lag is nonexistent, and processing delays occur only after shooting many frames in a short period of time. There is no magnification effect. If not for their high cost and weight, they would be the first choice for most photographers.

Larger Formats

A number of manufacturers offer high-quality digital camera backs for medium-format film camera bodies. Medium-format cameras use largerformat film—6cm x 4.5cm to 6cm x 9cm—which is several times larger than 35mm. Medium-format digital sensors are commensurately larger, too, and gather more information. While these offer amazing color and astonishing resolution (22 megapixels is common today), their price and weight put them out of reach of most photographers. Furthermore, the 35mm-format digital bodies are quickly catching up with the resolution of medium-format backs.

Some manufacturers produce ultrahigh-resolution digital camera backs for view film cameras. Nothing equals their resolution or rendition of color, including 4-inch x 5-inch film. This is the system for the fanatic landscape photographer. However, these backs make you suffer for your art. They require exposures measured in minutes, so the least puff of breeze causes problems. As one would expect, their prices are astronomical, but for anyone who can't and/or won't compromise, they are the way to go.

Туре	Features	Advantages	Disadvantages
Consumer	Small Fixed lens (zoom)	Lightweight Inexpensive Easy to use	Low resolution Mediocre lens Shutter lag Small sensor Slow processing
Prosumer	Better fixed (zoom) lens	Acceptable resolution More sophisticated electronics Lightweight Reasonable price	Only one lens Little shutter lag Processing delay Small sensor Fragile compared to professional type
Professional	SLR body	No shutter lag Sophisticated metering Accepts accessories TTL focus and metering Accepts many lenses	Small sensor Minimal processing delay Expensive Heavy Large buffer
Professional with full- size sensor	SLR body	Sophisticated metering TTL focusing Full-size sensor Accepts many lenses Accepts accessories Highest resolution No shutter lag	No magnification Expensive Heavy

LENSES

With film cameras, lens quality contributes more to the sharpness of the image than the camera body does. Because digital resolution depends on the capacity of the camera sensor, lens quality does not impact the character of the final image to as large a degree. Still, a poor lens will ruin an image in digital photography as well as it will on film.

When shopping for a lens, look for sharpness in the corners of the image area as well as at the center. Check for chromatic aberration: color fringing along sharp edges. Look out for vignetting—light falloff in the corners—a common failing in even high-quality wide-angle lenses. Some of these characteristics are represented mathematically as specifications or in reviews, but the effects can be seen in the images themselves.

The speed of the lens—in other words, its largest aperture—doesn't relate to sharpness. Faster lenses allow you to stop action or shoot handheld in low light at a given ISO (the imaging sensor's sensitivity rating), but the tradeoff is increased weight and a loftier price.

If possible, rent a lens before buying it, to confirm that it performs well enough for your intended uses.

Different lens focal lengths create different effects. Some compress depth; others enhance it. Some distort straight lines; others compensate for parallax problems. Specialized lenses focus closely, capture 180degree views, or maximize depth of field.

Note: Digital cameras with sensors smaller than a 35mm slide add a telephoto effect to each focal length.

Wide-angle

Useful for providing perspective, whatever the subject, wide-angle lenses are the mainstay of landscape photography. They permit greater depth of field than lenses with longer focal lengths. Wide-angles range from 11mm to 35mm.

Wider lenses tend to distort straight lines, especially when the camera is pointed up. When you are shooting a stand of pine trees with the camera pointed straight ahead, most wide-angle lenses will represent the trees as vertical lines. However, if you tilt the camera up, those vertical lines are forced to converge at the top of the image. Rectilinear wide-angle lenses minimize this effect, and the Free Transform command in Photoshop and other tools can bend the lines back to vertical.

Use wide-angle lenses for landscapes when a strong foreground element is present. Because of the great depth of field of a wide-angle lens, everything remains in focus (assuming you use the small aperture), even when the camera sits very close to the foreground.

Wide-angle lenses help to create a sense of scale and distance.

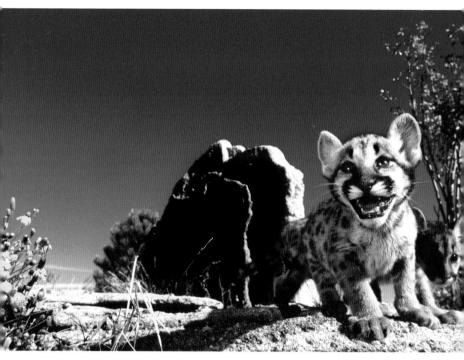

Since photographers use telephoto lenses for most wildlife shots, I look for any opportunity to use a wide-angle lens for a different perspective.

Foregrounds appear relatively large compared to background elements, emphasizing distance. Don't use wide angles to include everything you see. Good photographers select the most interesting and powerful components of a scene. Trying to capture everything in a single shot often results in a busy, confusing image.

Normal

A 50mm lens produces neither a telephoto nor a wide-angle effect on a 35mm film camera. It behaves the same way on a digital single-lens reflex (SLR) camera with a full-sized sensor. (With a smaller sensor, which creates a telephoto effect, a 35mm lens or thereabouts possesses the same angle of view as a 50mm lens with a full-sized sensor.)

It's easier and therefore cheaper for a lens manufacturer to make a sharp 50mm lens than a sharp wide-angle or long telephoto. Even inexpensive normal lenses tend to be sharp, light, and fast. Some professional photographers carry nothing but a 50mm lens on a camera body when exploring a city and grabbing shots.

Telephoto

Although most people think of telephoto lenses as a means for bringing distant objects closer, I prefer to think of them as a way to select the most interesting part of a cluttered or confusing scene.

When I first started shooting, I drove with professional photographers in search of images. As I drove, they would shout, "Stop. Stop." I hit the brakes and looked around, not seeing anything worth shooting. When they stopped photographing, I peered through the viewfinder

The telephoto lens can isolate your subject and place it in context while cutting out extraneous elements.

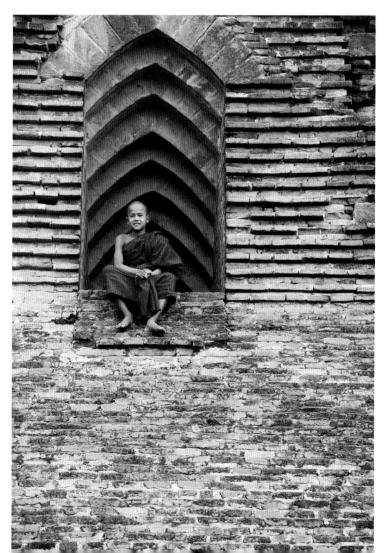

and was surprised to find a great picture embedded in the surrounding mediocrity. Once I understood the angle of view for each of my telephoto lenses, I began to look for compositions that fit them. I find I use telephoto lenses more than half the time, even for landscapes.

Use medium telephotos to photograph people in street scenes. You can work anonymously or introduce yourself and get permission. Fashion photographers use telephotos because they flatter the subject and isolate them from the background. You can do the same thing when shooting wildlife or people.

Super Telephoto

On a game drive in the Serengeti, you can expect to see batteries of big glass lenses bristling from the vehicles. I'm sure the lenses cost more than the Land Rover carting them around. When dealing with dangerous animals, there is no substitute (except courage or stupidity) for 500mm lenses or larger.

The best long lenses are huge. An f/4 600mm lens resembles a bazooka. They must funnel a lot of light to the film or sensor to allow

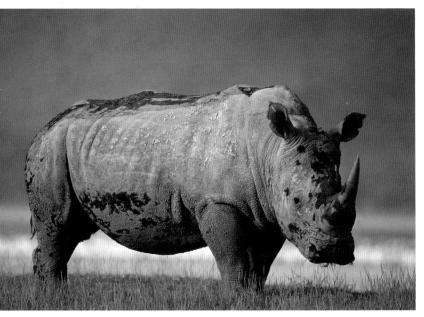

This super-telephoto image of a white rhinoceros compresses the background and isolates the animal. The colors in the background—a forest, a soda lake, and thousands of flamingos—become a wash of color due to the shallow depth of field of the long lens.

fast enough shutter speeds to freeze moving subjects. Not only are they fast, they remain sharp at all apertures. Super telephotos compress perspective and exhibit restricted depth of field.

Zoom versus Fixed

Although the quality of zoom lenses has improved tremendously, they still don't match the sharpness and color fidelity of top-flight fixed lenses. Stick with fixed lenses when you are going for ultimate quality. On the other hand, zoom lenses have no peer when it comes to capturing a fleeting composition. Because you can change the angle of view virtually instantly, frame the ideal image before conditions change; for instance, before the lion takes off or the sun goes behind a cloud.

It's vital to test a zoom lens before purchase. Pay particular attention to sharpness in the corners and to vignetting in wide-angle zooms.

Specialty

Some lenses offer limited utility but deliver extraordinary images when the situation matches their capability.

Fisheye. These lenses encompass a 180-degree angle of view. They necessarily distort straight lines in the image. I like to use them when I need tremendous depth of field and distortion is irrelevant or when the distortion contributes to the composition. For example, shooting straight up in a redwood forest with a fisheye lens gives the impression that all the trees are leaning toward the center of the frame. Sometimes nothing else works at all, such as inside a cave where you want to shoot straight up toward the ceiling and still include the surrounding stalagmites. Finally, fisheye lenses boast extremely wide depth of field. Everything, from just inches from the foreground out to infinity, stays sharp.

Tilt/shift. These lenses mimic the ability of view cameras to control parallax distortion and depth of field. Tilting the back of the camera or angle of the lens while the body remains stationary alters depth of field. Many spectacular landscape photographs that include wildflowers in the foreground and mountains in the distance with everything in focus result from tilts on a large-format view camera. A view camera's shift feature allows the lens to move up or down and from side to side to correct for parallax distortion (the same distortion a fisheye lense produces). Control of tilts and shifts permits a landscape photographer to create maximally sharp and in-focus images without parallax distortion. However, since straight lines are not common in nature, this capability is not critical most of the time, and digital photographers can use editing tools to mimic the effect of these lenses. Architectural photographers who deal with straight lines every day cannot live without these movements.

DIGITAL EQUIPMENT

A tilt lens controls depth of field; a right-angle finder makes lowangle work more comfortable.

A shift lens corrects for parallax distortion.

Macro. These lenses permit close focusing. Most don't exceed a 1:1 magnification; in other words, the image on the film or sensor equals the size of the subject. For greater magnifications, macro photographers turn to close-up lenses and extension tubes. For most photographers, a featherweight close-up lens (a magnifying filter) attached to a normal lens produces sufficient magnification most of the time. Specialists may use a 5x super macro and the full range of accessories: ring flashes, tubes, and focusing rails.

TIP: RIGHT-ANGLE FINDER

Before I discovered right-angle finders, I spent many hours groveling in the dirt, peering sideways through my SLR's viewfinder with my camera inches from the ground. While I got the perspective I wanted, composing a picture was a chore.

A right-angle finder consists of two tubes with a mirror where they meet at a right angle. It relays the image from the camera's viewfinder to your eye as you look straight down so you can compose from a dignified crouch instead of a sloppy sprawl. A diopter in the finder corrects for poor vision.

Owners of digital cameras with swinging liquid crystal display (LCD) screens already possess a de facto right-angle finder.

AUTOFOCUS VERSUS MANUAL FOCUS

Autofocus is a standard feature on modern cameras. It's a godsend for photographers with imperfect vision. When shooting running or flying wildlife, athletes, or other moving objects, servo-focusing (focus tracking) locks onto the subject and captures sharper images than even the best pro could shoot with a manual focusing lens.

Even with its great strengths, autofocus is stupid. It can't decide what part of an image matters, at least not all the time. In a tight portrait of a wolf, it's just as likely to focus on the nose as the eyes. The photographer must ride herd on the system lest it go astray.

Most systems allow you to set the focal point in the viewfinder; in other words, to place it in the center or to the side. Very sophisticated systems "guess" by applying probability calculations based on a huge database of common situations. Even these systems fail in uncommon situations.

I prefer to keep things simple by leaving the focus point in the center of the frame. I hold down the shutter button halfway to focus on the primary subject and then, while still depressing the button halfway, reframe for the composition I want. As long as I don't release the button, the lens keeps the focus I set. If I know I will take several shots or reframe while keeping the same subject in focus, I set focus and then turn off autofocus.

Most cameras have a focus lock feature. This behaves the same way, but with my method I never need to fumble through menus to find it. A few cameras allow you to assign a button for focus so the shutter no longer triggers it, which accomplishes the same thing.

Often, using manual focus saves time. Close-ups usually confuse an autofocus system. What in the frame should it select for sharpest focus? the base or the tip of the stamens? the rims of the petals or their origins? Flip off autofocus and adjust focus yourself.

Although focus tracking can perform miracles, it can't deal with every situation. If a subject passes in front of the lens momentarily, autofocus can miss the moment by hunting for the right thing to lock on. Imagine that you're set up under a jump where a mountain biker soon will fly by. Switch to manual focus and focus on a point the same distance from you as the mountain biker will be. When the biker zooms through the zone of focus, you are ready to capture the moment.

FILTERS

Although the digital domain allows us to mimic most photographic filters electronically, it's often easier to use a filter in the field instead of correcting on the computer. My old warming filters stay at home these days, but I always carry a polarizer and at least one graduated neutraldensity filter. Replicating some polarizer effects are impossible in Photoshop, and in some situations a graduated neutral-density filter effortlessly equals computer correction.

Polarizers

Most people use polarizers to darken the sky. Polarizers create this effect in the right conditions, but it is their least important effect.

When light strikes dust in the air or on a reflective surface such as water or metal, it scatters. We experience this as haze or glare. A polarizer blocks scattered light—light arriving from the sides—so that only coherent light passes through the lens, removing the glare and revealing colors.

Turn the front element of the polarizer to find the most useful setting. The effect grows strongest at 90 degrees to the light source. For example, a polarizer will do nothing to reduce the appearance of haze when the sun is at your back but will drastically darken the sky if you make a quarter turn to the right or left. A polarizer pointed toward the sun produces no effect on the sky.

Glare on water obscures color and detail. Polarizers remove glare, restoring a forest stream from a flat ribbon of white glare to a dark, variegated rush of water. Don't even think of shooting tide pools or

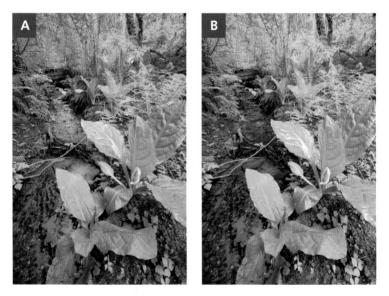

A polarizer suppresses glare. A. Without polarizer: Note how the glare obscures the surface of the creek and the color of the large leaves. B. With polarizer: The polarizer cuts glare, allowing the stream bed and the saturated green of the leaves to appear.

lakes without a polarizer. The detail revealed by the polarizer cannot be recovered by computer manipulation.

I always use a polarizer when photographing plants or forests. At first glance, a forest looks like a riot of green and brown, but that impression springs from the brain's editing. In fact, most leaves shine with glare. Film records the glare as bright white, creating a contrasty image. A polarizer cuts the glare, revealing the underlying green while increasing the saturation of all colors. Polarizers enhance color saturation for many subjects even when glare is a minor problem. Clothing, hair, and smooth surfaces all pop more dramatically.

Polarizers can ruin shots, too. They diminish light, up to two stops' worth; in low light conditions, the resulting loss of shutter speed may prohibit handheld exposures or allow subject movement to compromise sharpness. When used on a very hazy sky, polarizers can produce a disagreeable gray effect not found in nature. A blue sky may become black when a polarizer is used full strength, or it may turn an unnaturally dark blue, especially at high altitude. Although this effect can produce a dramatic image, more often than not it distracts and detracts.

Used judiciously, a polarizer will do more to improve images in the field than any other filter. Opt for a circular polarizer because linear models can confuse autofocus systems.

TIP: USING A POLARIZER

When using polarizers on viewfinder cameras, it's impossible to see how much effect it's having once it's on the camera. Furthermore, polarizers require between one and two stops of exposure compensation. Cameras without through-the-lens metering will underexpose by that amount unless they are set to compensate. Two steps remedy these problems.

First, hold the polarizer in your hand and look through it toward what you wish to photograph. Turn the polarizer in your hand until it produces the result you want. Look for writing on the outside edge of the filter and note which way it points. After screwing the polarizer on the lens, turn the polarizer ring until the writing faces that way again.

However, before fixing the polarizer to the lens, hold it in front of the light meter sensor on the camera body and take a reading. The exposure will increase by one or two stops. This is the correct exposure. After putting the polarizer on the lens, set the camera to that exposure no matter what the light meter reads.

Graduated Neutral-density

Graduated neutral-density filters (GNDs) help control excess contrast. Film and digital sensors see only five stops of contrast, whereas the human eye can resolve eleven. For example, when we look at a sunset with the foreground in shadow, the sky may be eight stops brighter than the darkest part of the foreground. If we expose for the sky, the foreground turns black, but if we expose for the foreground, the sky loses all color. If we expose for midtones, both sky and shadow lose most detail, becoming undifferentiated white and black. The solution? GNDs work perfectly for ocean sunsets or other situations in which the boundary between bright and dark is a straight or nearly straight line, by darkening the bright part of the frame.

GNDs consist of a glass or resin, clear on one half and tinted neutral gray on the other. They come in one-, two-, and three-stop strengths, each with a gradual or abrupt transition. With a rectangular GND, we can move the filter in front of the lens so the line of demarcation matches the area where radical change in brightness occurs—such as at the horizon line in the example above. I always carry, at minimum, a rectangular two-stop GND with a gradual transition.

To use the GND filter, slide it into a special rectangular filter holder (Cokin is a popular brand) or hold it against the lens. If you hold the GND, make sure no gap exists between it and the lens; otherwise, the filter will bounce unwanted reflections into the lens. Hand-holding the filter almost requires using a tripod. However, I prefer to hand-hold the filter because I can work faster, though I must concentrate on avoiding transmitting vibration mechanically and on holding the GND motionless during a long exposure.

Adjust the filter so the transition area aligns with the horizon. When tall objects project into the bright sky, the filter darkens them when it shouldn't. In these cases, mimicking a GND in Photoshop or another program will produce more natural results because the computer applies filtering to areas that are actually bright, not to regions above an imaginary line.

When exposing with a GND in place, center-weighted metering (the default in most cameras) works most of the time. Spot metering through the filter, taking care that the light passes through the correct part of the filter, should give the same result as center-weighted metering. The spot-meter setting samples a narrow angle of view so you can meter highlights or shadows without the surrounding scene influencing the reading.

TIP: HAND-HOLDING A GND

If the horizon is a little jagged, rather than a straight line, try moving the filter slightly during exposure. This will blur the demarcation between darker and lighter. Take care to avoid moving the camera during this procedure.

Color Correcting and Warming

Color correction filters adjust color to compensate for shifts in hue induced by shadows or film color temperature. Warming filters remove the blue cast found in shaded areas under a clear blue sky. Tungsten film and other formulations designed for the color temperatures of artificial lights require compensatory filters in daylight.

Color-correcting filters are passé in the digital world. Photoshop CS includes digital color correction filters; numerous plug-ins mimic their effect; RAW editors (see RAW section later in this chapter) offer color temperature modification of RAW files; and most digital cameras provide for various color temperature settings. Because these adjustments are available with the click of a button, carrying a bundle of filters to compensate for cool open shade or yellow incandescent light no longer makes sense when shooting digitally.

TRIPODS AND HEADS

Tripods are vital and often cursed tools. No one relishes carrying the extra weight, but their benefits are many and essential.

The small apertures needed for great depth of field demand slow shutter speeds. Nobody can hand-hold a 15-second exposure and expect a sharp image to result. Super telephotos are too heavy to hand-hold, even when you are panning. Unless you are using very fast shutter speeds, you can't hand-hold a GND filter successfully.

The bigger the camera and lens, the bigger the tripod and tripod head must be. Mass provides a sturdy platform and dampens vibration. You can add mass in the field by hanging a camera bag from the tripod if carrying heavy loads is an issue.

Tripods force us to slow down. This gives us time to consider composition and to notice details that augment or diminish the final image.

Choice of materials affects performance. Aluminum tripods conduct more cold and vibration than wood or carbon-fiber tripods. Aluminum tripods weigh more than equivalent carbon-fiber models, too; however, carbon fiber exacts a higher price. After handling a metal tripod on a cold day and lugging it over hill and dale, you might find that the extra cost of carbon fiber seems trivial. Tripod heads come in two versions: ball head and panning. Most outdoor photographers prefer ball heads for their quick versatility. You can position the camera as you wish without fussing with the tripod legs.

Super telephotos work best on a C-shaped tripod head pioneered by Wemberley in 1991. The camera and lens balance inside the C on a gimballed plate so the weight doesn't shift no matter the angle of the lens. This prevents tipping, a potentially expensive disaster. Kirk Enterprises manufactures a similar gimballed head, the King Cobra.

Panning heads move only vertically and horizontally, so further adjustment requires changing the length of the tripod's legs.

PHOTO-EDITING PROGRAMS AND FILE FORMATS

When a digital camera records an image, the information consists of code written by the camera's software. No photo-editing program can interpret this information and shape it into a photograph. First, software must convert the data into a file in an imaging format such as JPEG or TIFE. Once we shot film; now we create files. The difference is more than chemistry and physics; it represents a new way of looking at the finished product.

Before you take your first digital picture, you need to decide what file size and file type will satisfy your requirements. For example, if you want to send a picture of the dog to Grandma in an email, a highly compressed JPEG file will do the job nicely, but that same file would be rejected by any magazine photo editor. Stock-photo agencies insist on very large TIFF files, currently on the order of 50 megabytes.

TIFF

Tagged image file format (.tif) is an uncompressed or "lossless" file format. It is the standard in the imaging industry and works across platforms; in other words, it works on both PCs and Macintoshes. If you need to send a file to a publisher or agency, TIFF is the way to go.

Photoshop

Photoshop (.psd) files resemble TIFFS in that they are lossless. An 8-bit PSD is the only uncompressed file format wherein all the features in Adobe Photoshop work.

JPEG

Joint photographic experts group (.jpg) is a compressed file. Compression reduces file size, sometimes dramatically. An 18-megabyte file collapses down to 1 megabyte. When you open an image after compression, the system re-creates the missing pixels through interpolation, a kind of digital guessing. Unfortunately, with each compression of a JPEG file, pixels disappear forever. After a series of saves, much or even most of the original pixels vanish. If you look in a highly compressed JPEG file on your screen at 100 percent, it's easy to see jagged, checked patterns. This is especially noticeable when the image has sharp features such as straight edges.

Compression is useful when you need to send an image over email or display it on the Web, but it is a poor choice for archiving. If you must shoot in JPEG format, photograph at the highest available resolution setting and save the files as TIFFs or PSDs before saving the JPEG. This creates an archival file that preserves the maximum amount of information.

RAW

As the name implies, a RAW file is uncompressed and unprocessed. In order to be manipulated in Adobe Photoshop or other editing programs, it must be converted to another format such as JPEG or TIFE However, a RAW editor program permits manipulation of a RAW file (actually a copy of the original) without losing any original data. Thus, one may alter saturation, color, brightness, contrast, and other attributes without losing information in the original file. Even after saving the file, you may return the image to its original settings. Once these enhancements have been performed, the RAW file can be converted to a 16- or 8-bit TIFF or PSD file format for additional work in Photoshop or a similar editing program.

Serious photographers should shoot in RAW format. It provides the most versatile and information-rich digital negative because each RAW file contains unprocessed information. When software converts the camera's data into an imaging format such as JPEG or TIFF, some information is lost with each adjustment of color, contrast, or brightness in its new format. To see how this happens, open the histogram for a new TIFF file. A TIFF with dark, midrange, and bright areas will look like a stock-exchange graph with no gaps. Then adjust the levels and curves, fiddle with brightness and contrast, and add a color cast. The histogram will now have gaps—in other words, lost information. Compression formats such as JPEG compound the problem by tossing out data each time the file is saved.

A host of other file formats are available. Some work best in certain operating systems; others are targeted toward specific uses such as text or raster (line-art) graphics; in other words, not photo files.

This RAW file looks too dark, lacks contrast, and appears desaturated.

Boosting Exposure, Shadow, and Color Temperature makes the image look like it was shot on saturated film.

RAW versus JPEG chart			
File Format	Advantages	Disadvantages	
RAW processing	Large file size Preserves pixels RAW editor powered	Slow camera Eats memory Not widely used yet	
JPEG	Small file size Most common format	Loses pixels Lower resolution Generates noise	

RAW Editor Programs

These retain the original information as they alter the image. The instruction set changes the values for color, brightness, and so on without affecting the original pixels. Thus, you can change all the settings and then change them back without altering the pixels in the RAW file. This also allows you to change your camera settings after you've taken the photograph. If the camera's white balance was set for bright sun (about 5500° K) but you shot in open shade, the image will appear blue. Changing the file to the proper white balance setting corrects the image without changing the original pixels.

Camera manufacturers such as Nikon and Canon have developed proprietary RAW editor programs. Some claim that using a camera manufacturer's proprietary RAW file converter has inherent advantages. They argue that only software designed for specific cameras can compensate for in-camera processing and other manufacturer-specific idiosyncrasies. If this is so, the advantages are exceedingly subtle.

The manufacturers' programs may optimally compensate for lens deficiencies; they know how their lenses vignette or generate chromatic aberrations. That should allow them to optimize RAW editor settings to repair inherent lens problems. However, filters induce analogous aberrations, and the manufacturers' software possesses no advantages when filters degrade the image.

In my opinion, work-flow efficiency counts more than these tiny improvements in accuracy. Adobe RAW works seamlessly with Adobe Photoshop, and Phase One's Capture One delivers unparalleled ability to process a large number of images with maximal control. Since the camera manufacturers include their software with their cameras, compare their results against Adobe RAW or other similar programs and decide which system allows you to work the way you prefer.

Using Adobe RAW, now included in Photoshop CS, we can adjust and correct many aspects of the RAW image before conversion. You

The RAW editor has sliders to boost or cut color, brightness, and contrast.

can open a RAW file by double clicking on its thumbnail in File Browser or with the Open command in the File pull-down menu. The RAW editor opens automatically, displaying the image and a set of sliders in the Adjust menu for altering white balance (temperature and tint), exposure, shadow, brightness, contrast, and saturation. A histogram displays red, green, and blue (RGB) channels. You can toggle between 8 and 16 bits and between various color spaces. The program provides for setting resolution and altering image size. A zoom tool permits close inspection of the image, and an RGB histogram reflects the tonality of the image.

The Advanced button at the top right of the editor reveals two additional menus. The Lens menu corrects for Chromatic Aberration (colored fringes seen on sharp edges in an image) and Vignetting (darkening around the corners of an image due to light falloff). Moving the sliders to the right corrects these problems. The Calibrate menu contains hue and saturation sliders affecting Red, Green, and Blue.

Given that changing any setting won't harm the original file, the RAW editor program delivers unprecedented power in optimizing and enhancing images. For example, you can boost a washed-out image by increasing saturation, warming with temperature, and boosting shadow. Drag an overexposed image into perfect balance with the exposure slider in seconds without altering a pixel. Then save your results under different file names to preserve the original. You can save a cluster of settings in the Settings menu.

16 Bits in an 8-bit World

Each channel of a 16-bit file can differentiate between 65,536 levels of brightness, whereas 8-bit works with only 256 levels. Every file alteration discards information. These losses are insignificant in 16-bit but critical in 8-bit. If the program tosses 25 red tones in 8-bit, it removes 10 percent of the red information. The loss of those same 25 tones in 16-bit represents less than .05 percent of available colors.

To view these differences, compare 8-bit and 16-bit histograms. Open an original 16-bit file. Go to Mode in the Image menu and select 8-bit. Open the original 16-bit file again so you have both the 8- and 16-bit versions on the screen. Open a histogram for each. (Go to Histogram on the right side of the Navigator palette. If Navigator is not present, clicking on it in the Window pull-down menu will open it.) The two histograms should look identical.

Open Curves for the 16-bit image. Perform a complete color correction for each RGB channel: midtones, highlights, and shadows. (See Correct Color and Contrast in Chapter 5, Work Flow, for details.) Repeat for the 8-bit file. Finally, compare their histograms. The histogram for the 16-bit file won't change appreciably, but the 8-bit's will resemble a comb. White lines indicate lost information, irreplaceable tonal information the program discarded.

Few editing tools worked on 16-bit files before Adobe released Photoshop CS. Now, the tools photographers require the most—color correction and layers—work on 16-bit files. Do as much editing in 16bit as possible and save the result as an archival file.

Opposite: Zebus pull two men through a gathering storm in Madagascar.

Taking Digital Photographs

3

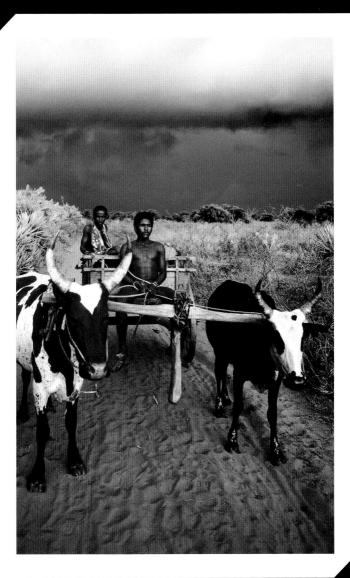

lthough most of the precepts of film photography work when shooting with digital cameras, digital photography demands a few alterations in the way we shoot. Capturing an ideal exposure in digital requires a shift in technique. Decisions on file types, color temperature, and file transfer must be

addressed before taking a single shot. Photographers using a digital SLR must fear dust or resign themselves to hours spent despeckling their files. Finally, imagining how an image can change in the computer and shooting to create the best raw materials are the keys to harnessing the full power of digital photography.

OLD-SCHOOL EXPOSURE

Exposure—the amount of light reaching film or a sensor—is often determined by using a light meter. A light meter measures the intensity of light falling on its photosensitive cell. In-camera meters detect light reflected off the subject; handheld incident meters measure light falling on a subject. Meters are calibrated to define ideal exposure as 18 percent neutral gray, approximately midway between black and white. It doesn't matter what the subject is; meters always suggest an exposure in which tones average to neutral gray. Metering green grass or a blue summer sky works ideally.

However, the same meter measuring light reflecting off snow will suggest underexposing enough to turn the snow gray. To expose correctly, the photographer must compensate by overexposing between one and a half and two stops to restore the correct amount of brightness.

The meter commits the opposite mistake in a very dark scene such as a black bear standing in shadow. In this case, it suggests an exposure converting the black bear to gray. To compensate, the photographer must deliberately underexpose between a stop and a stop and a half. See the Exposure Compensation section later in this chapter.

Light Metering Modes

Advanced cameras offer several metering modes: typically, these are average metering, spot metering, and matrix metering. Rather than depend on any automatic system, learn to recognize the conditions that cause meters to lie and compensate manually.

Average metering. The light meter averages the brightness of the whole scene.

Spot metering. The light meter focuses on a small part of the frame. This works wonderfully when the scene contains a medium-toned object

such as a sunlit deer in a dark forest. By spot metering on the deer, we determine the correct exposure, whereas an averaging meter would insist on overexposure. We can also check highlights to make sure our exposure won't blow out bright details.

Matrix metering. This applies algorithms to guess how to expose a complex scene. Sometimes matrix metering performs miracles. Matrix systems may nail backlighting every time, but other situations might trip them up.

Estimating Exposure Settings

Ask any pro. Determining correct exposure can confound experts, even after years of practice. There are many techniques but no single right answer.

I participated in a shoot with a group of professionals photographing captive raptors in Colorado. John Shaw, a respected nature photographer and author of some of the best instructional photography books, attended the shoot. Many times each day, one of the other photographers would call out, "What's the exposure, John?" He dutifully played his part as human light meter, explaining how to determine the correct exposure for the light and the subject. For instance, it was a bright bluebird day.

John depended on the Sunny 16 rule, which is always simple, infallible, and even easy when conditions are right. If your camera's shutter speed is accurate, nothing beats Sunny 16. Sunny 16 means setting your shutter speed as close to the ISO as possible, with your aperture at f/16 for a front-lit subject on a sunny day. Thus, a digital camera set at ISO 100 would have a shutter speed of 1/125 second (the closest shutter speed to 100) at f/16. Open up one stop for sidelight and two stops for backlight. Thus, the backlit exposure on a sunny day would be1/30 second at f/16.

Remember that f/16 at 1/125 second represents only one way to get a given exposure. If you open the aperture one stop (f/11), which lets in twice the light, you overexpose one stop. Doubling the shutter speed halves the light. Thus f/11 at 1/250 second is the same exposure as f/16 at 1/125. F/4 at 1/2000 second is the same exposure (with much less depth of field).

Other lighting situations or difficult subjects require specific compensation (see the Sunny 16 Chart). Open one stop from Sunny 16 for light overcast (f/11) and two stops for heavier overcast (f/8). When no shadows are visible in midday, opening three stops is required (f/5.6). With really bright subjects, such as snow or a brightly lit beach, stop down one stop (f/22).

TAKING DIGITAL PHOTOGRAPHS

sunny 16 chart			
Light	Shadow Detai		
Sunny	Distinct		
Slight overcast	Soft edges		
Overcast	Faint		
Heavy overcast	No shadows		
	Light Sunny Slight overcast Overcast		

Other photographers habitually employ different techniques. Art Wolfe usually looks for a medium-toned component of the scene and reads the reflected light with the spot meter in his camera. Jim Zuckerman prefers a handheld incident meter to measure light falling on the subject; however, most of the time, he predicts the correct exposure within half a stop no matter how difficult the light. When he explained how he does it, it made my head hurt. Some digital photographers depend on the histogram (a bar graph, available on the LCD screen on digital cameras, that measures light intensity across the visible spectrum) to confirm that they nailed the exposure.

Each of these methods can yield good results, but Sunny 16 never fails—although the photographer may. John Shaw recommends calibrating your in-camera meter against the Sunny 16 rule (see Tip: Calibrating the Meter) because most in-camera meters are a little bit off, sometimes as much as a whole stop. John sets the ISO on his cameras so the meter matches Sunny 16. The meter then delivers the correct exposure. Compensating with ISO works only for film cameras. With digital cameras, set Exposure Compensation to adjust for the metering errors.

TIP: CALIBRATING THE METER

If the meter recommends f/11 at 1/125 second at ISO 100 for a front-lit subject on a sunny day, the resulting exposure will be one stop overexposed, because according to the Sunny 16 rule the correct exposure should be f/16. Setting the ISO at 200 or 250 (or setting Exposure Compensation to -1) tricks the meter into suggesting f/16 at 1/125 second, a correct exposure for Sunny 16. The meter is now calibrated without the expense of a trip to the photo technician.

Exposure Modes

Digital cameras come equipped with various exposure modes designed to simplify capturing a good exposure. Except for Manual and some Program settings, they all deliver an average exposure. In other words, shutter speed and aperture may vary for each mode, but they all allow the same amount of light to hit the sensor, based on an averaged reading of the scene.

Manual. In manual mode, the photographer decides whether to over- or underexpose and how to select aperture and shutter speed. If you want to shoot Sunny 16 or learn how to control every aspect of exposure, practice with Manual to learn how meters behave and how to determine optimal exposure when lighting deviates from 18 percent gray.

Program. Program, or matrix metering, employs complex algorithms to deduce the correct exposure. Sometimes they nail tough exposures such as a dark backlit scene, but just as often they fail when things get complex. They also have a bias for faster shutter speeds, as if they expect everyone to hand-hold the camera. Use this setting when subjects and light change quickly and unpredictably.

One time when I was in Africa, a herd of elephants surrounded my vehicle. They were front-lit, backlit, and sidelit; they were standing, walking, and waving their trunks. I switched lenses while they approached and as they skirted the Land Rover. I didn't have time or the inclination to determine exposure, and the Program setting performed splendidly amid the stately chaos.

Aperture priority. This is an averaging setting in which the aperture remains fixed and the shutter speed changes to accommodate different light intensities. This is the automatic setting of choice when you need to define a specific depth of field and shutter speed doesn't matter. For a landscape in which everything from foreground to infinity must remain in focus, set the camera to a small f-stop, such as f/16. If you want a shallow range of focus to isolate a flower from its background, set the aperture at f/2.8 or thereabouts.

Shutter priority. This is an averaging setting in which the shutter speed remains constant and the aperture varies to suit light intensity. Use Shutter Priority when depth of field doesn't matter but shutter speed does. If you wish to freeze the motion of a running deer, set shutter speed at 1/250 second or faster. The aperture will open wide so depth of field will collapse, but the deer will look sharp. If you want a blurred effect for moving water or while panning on a moving object, set the shutter at a slow speed.

Subject icons. Many digital cameras come with exposure modes suited to particular subjects represented by icons. A flower icon signifies macro; a running man means action mode. These modes combine exposure and focus settings to match these subjects. Since most landscape shots require maximal depth of field without regard to shutter speed, selecting the mountain icon (or equivalent) will set the camera to a small aperture and slow shutter speed; selecting the running man will do the reverse.

Exposure Compensation

When a scene deviates from neutral gray, automatic settings require compensation, and modern cameras include ways to enter the amount needed. For example, a bright snowy scene needs one and a half to two stops of overexposure. Setting Exposure Compensation to $1\frac{1}{2}$ tells the camera to let in the extra light. In manual mode, simply alter the exposure to compensate.

DIGITAL EXPOSURE

The principles of digital exposure differ slightly from those for film exposure because a digital sensor "sees" light differently from how film or the human eye "sees" light. However, the same good exposure practices prevalent when film ruled are still relevant.

Many digital cameras display a histogram, a jagged graph that looks like a stock-exchange chart during interesting times. The spikes and flat lines represent the relative amount of light at each frequency of the visible range. The histogram for a dark picture with lots of shadow will be heavily weighted toward the left. A snowfield on a cloudy day will shift the histogram to the right. Since a histogram reveals the distribution of light by frequency, it acts as a retroactive light meter.

Film and a digital sensor have similar dynamic ranges. They record the same number of stops between black and white: between five and six. From an 18 percent midtone, both film and a digital sensor record information up to two and a half stops brighter and two and a half stops darker. Because the human eye can see ten stops, this limitation of both film and a digital sensor means a photographer must decide what part of a high-contrast scene is most important. However, both formats can deal with this insensitivity to a greater or lesser extent.

Light Sensitivity

Film and digital sensors record light values differently. Let's look at highlights, which illustrate the two major differences: how each handles the brightest and darkest parts of an image and how each differs regarding sensitivity to light and dark.

When film captures the brightest elements in the picture, it gradually loses its ability to resolve detail as brightness increases. A digital sensor increases the amount of information it records as brightness grows and then loses it abruptly at a certain level of illumination. Film records about the same amount of information throughout its range until it tails away at the luminosity extremes. A digital sensor records most of its information at the bright end of the scale. In fact, over a sensor's five-stop range, fully half of the information is contained in the brightest stop. Very little information remains in the darkest stop. If you try to boost the brightness of a dark area of an ordinary exposure, the file will generate noise (the digital equivalent of film grain) and posterization.

"Exposing to the Right"

When shooting digitally, you can increase shadow detail and decrease noise by "exposing to the right." This allows the sensor to capture the maximum amount of information. The resulting image will appear overexposed, but adjusting brightness on the computer will restore proper color and tonal balance.

Take a test shot and check the histogram on the camera. An average exposure will produce a bar chart with flat lines at the right and left margins, which tells you that there is little information at the exposure extremes.

Now overexpose the next shot so that the histogram information almost touches the right-hand border of the chart. If the histogram indicates that the exposure exceeds the sensitivity of the sensor and blows out the highlights (known as *clipping*), reduce exposure slightly. When the right-hand information almost touches the right side of the histogram, you know you have captured the maximum amount of data. The resulting image will appear much too light, but you can reduce brightness in RAW editor or another editing program (see the next section). This ideal exposure displays the greatest tonal range and fewest artifacts. Reducing brightness in a RAW editor program causes no loss of information, a superior feature of RAW files.

Overexposing to move the histogram to the right resembles shooting with lower ISO film. Slower film tends to have finer grain. Shooting to the right (overexposing) with a digital camera requires longer exposures or larger apertures and produces less noise (digital "grain").

This technique produces only subtle differences; however, if you wish to make a large print in which shadow and highlight detail are important, this technique delivers the highest quality. When I'm shooting a neutral scene without important highlights or shadows, I don't bother exposing to the right. Once I'm home, I save computer time without sacrificing significant detail.

Noise

Digital cameras introduce noise during long exposures. After only a few seconds' exposure, tiny dots resembling snow appear in the image's

dark areas—that's noise. Because exposures shot at the first and last light of the day often require 30 seconds or more, especially with low ISOs or small apertures, noise is a concern. Noise will obliterate a twohour exposure for star trails.

Digital cameras feature noise suppression. Adobe RAW in Photoshop CS, most other editing programs, and a herd of plug-ins tackle noise in the computer, which provides some benefit.

But sometimes noise enhances an image. Photoshop includes a scalable filter for introducing noise to an image to mimic high-ISO films. A high-contrast black-and-white image, with minimal Gaussian blur applied, takes on the features of an infrared image after noise is added.

BEFORE SHOOTING

Testing equipment and redundancy prevents most digital mishaps from spinning into catastrophes, although gremlins will always be with us. Before leaving home the first time, make sure all your equipment works together.

Set the White Balance

Before shooting, set your camera's white balance to deliver the effect you want. White balance adjusts color temperature so that white objects appear white. Most digital cameras provide for automatic settings, color temperature presets, and manual calibration.

Automatic white balance. The automatic setting evaluates a scene captured by the sensor. The camera's algorithms—a set of instructions and assumptions—essentially guess which white balance will produce unshifted color. In practice, auto white balance delivers adequate calibration that frequently desaturates colors present in the scene. Auto settings can drain color from a sunset as they try to create white whites.

White balance presets. These do a decent job when you know the approximate color temperature of the scene. These presets are usually represented by icons such as a sun or a lightbulb. Although these presets merely approximate optimal settings, they work well enough for most applications.

Film photographers who are converting to digital feel comfortable using the daylight setting since it replicates the white balance of traditional daylight film. It captures the warm tones of magic light and endows most subjects lit by artificial light with a yellow or green glow.

Manual white balance. You can calibrate the white balance of your camera manually to guarantee an ideal setting. Take a picture of a bright white card with a fine line drawn through it. Ensure that no objects with bright colors are adjacent to the card, because they can

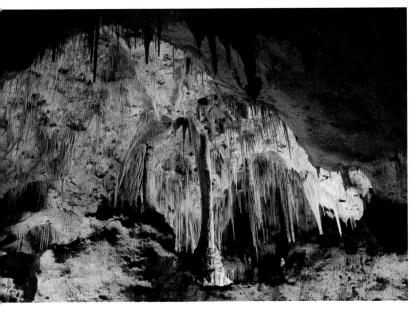

By setting the white balance on my camera to daylight, the color became warmer in the Carlsbad Caverns. A color-corrected image would have appeared dull gray.

reflect colors onto the card. Overexpose by one and a half to two stops to obtain proper exposure. If you overexpose more than that, the line drawn on the card will look too pale. When you have the right exposure, you can use the camera's manual white balance procedure to complete the calibration.

No law insists you must employ a neutral white balance. You can calibrate with a color opposing your desired hue. For example, a light blue card will add warmth to a scene; a light yellow card will cool it down.

Turn Off In-camera Sharpening

Before you shoot, turn off in-camera sharpening. If you can't turn it off, use the lowest setting to reduce the effect.

Check Memory Cards

Add up how much memory you carry. Calculate how many shots you can get on a memory card in the format you choose. I like to carry enough memory cards to shoot twice as much as I expect on the busiest day. You can stretch your cards' capacity by editing in-camera during the

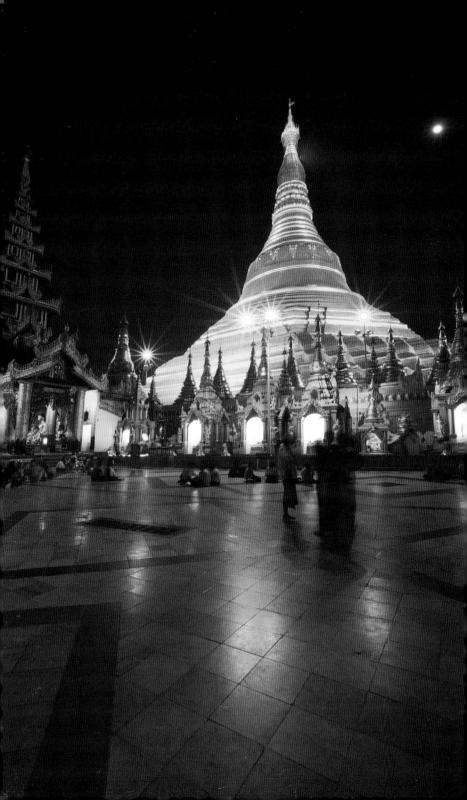

BEFORE SHOOTING

day and deleting the obvious mistakes. Just remember that reviewing images with the camera LCD screen gobbles battery power.

Decide how much faith you want to place in a single memory card. As the capacity of memory cards increases, the potential for disaster grows as well. With my 11 megapixel Canon, a 2-gigabyte card gives me about 168 images when I shoot in RAW format. That translates to a little more than four rolls of film. If the card fails for any reason, that is the limit of my risk. A 4-gigabyte or 8-gigabyte card, although convenient when shooting, doubles and quadruples the risk. If I were to photograph in the compressed JPEG format, I could lose thousands of images and days of effort in a moment. The wise digital photographer will carry a few smaller cards instead of a single big one.

Check Image Storage Systems

Most storage in the field relies on hard-disk drives. These are inherently fragile, so bring two when possible. I travel with a digital wallet and a subnotebook computer, and each night I download my memory cards to both machines. At home before you head into the field, download your memory cards into the digital wallet. Move those files to a computer and confirm that they arrived uncorrupted. Download the memory card directly into your laptop and desktop computers. Most computers don't have a slot for reading memory cards. A card reader is an interface that plugs into a USB, USB-2, or FireWire port. Choose a card reader that plugs into your fastest port. USB-2 is the fastest, followed by FireWire (IEEE 1394) and USB. If you are shooting RAW files and depending on a digital wallet with a screen for editing, make sure the wallet can read that format.

In the field, I also carry some blank CDs so I can burn the best images periodically. Whatever system you choose, familiarize yourself with the sequence of your work flow and the operation of each digital tool before you hit the road.

When traveling to a foreign country, bring an assortment of adapter plugs. Retailers and websites specializing in foreign travel can point you in the right direction.

Opposite: The dome of the Schwedagon in Yangon (Rangoon), Burma, is covered with more gold than the British treasury. I opted for a 30second exposure so most of the wandering tourists would blur into invisibility, and I enhanced the gold color of the dome by keeping the white balance set on daylight.

Image storage systems, left to right: digital wallet, memory card and card reader, notebook computer

Pre-shoot Checklist

Nothing is more disappointing than equipment failure, unless it's operator failure. The digital work flow can break down in both these ways, in myriad fashions. In addition to the usual camera failures, you can experience memory card malfunctions, digital wallet crashes, computer meltdowns, recharger mishaps, and battery collapse. Compound these miseries with incompatible connectors, missing cables, operating system conundra, and conflicted formatting, and you begin to envy the film photographer shooting with an old mechanical Leica rangefinder that still shoots with a dead battery.

Paranoia is a healthy state in the digital world. Make sure everything you need is packed and ready before you leave.

- 1. Recharge all rechargeable batteries, including those in wallets and computers. Bring extra batteries for flash.
- 2. Test and clear your memory cards.
- 3. Lay out your computer and other storage devices.
- 4. Lay out all cables and power supplies (I like to keep mine in labeled resealable plastic bags).
- 5. Lay out chargers.
- 6. Lay out the primary camera and backup body.
- 7. Lay out lenses, filters, flashes, cleaning supplies, and whatever accessories you use, such as reflectors.
- 8. Don't forget the tripod.
- 9. Clean everything, especially the camera sensors.
- 10. Check to confirm that your camera settings conform to your preferences or the situation you expect to find. Look at ISO, white balance, file format, focus and exposure setting, "motor drive," and exposure mode. Otherwise, a fleeting opportunity may pass you by while you fiddle with the body. Worse, you

could fire a burst at a startled critter only to discover that the camera was set for low-resolution JPEGs using aperture priority set at f/22, leaving you with one blurry, pixelated image.

IN THE FIELD

A digital photographer must carry a load of gear in the field. You must pay attention to transporting the gear, keeping it operational, and preserving the images. After you are satisfied that everything is ready to go, pack it in your camera bag. You may need to transfer items to other bags for transport, but make sure you can carry your kit once you are on site.

Carrying the Gear

Whether you are embarking on a full-scale expedition or just a stroll down the street, you have to carry the gear somehow. There are infinite variations of shoulder bags, suitcases, and backpacks designed for photographers. Your choice depends on how and where you photograph.

Rigid suitcases protect gear the best, and some are waterproof enough for river trips—and they even float. Usually composed of metal or rigid plastic, they come with open-cell foam on the inside. Cut the foam to fit each piece of equipment. This defends against shock, dust, and moisture. The shiny metal versions reflect heat, which affords some protection to delicate electronics in very hot climates. On the downside, they become very heavy when fully loaded, so walking around with them is like carrying a dumbbell in one hand. They scream "professional photographer," an invitation to thieves. I use them when I must check baggage, but I place each one in a cardboard box to camouflage its value. When I arrive at my destination, I transfer the gear to a more convenient case.

It's easy to work out of a camera bag with a shoulder strap. Most open from the top, so you can see all your gear at once. I find they work well when I carry a single camera body and a couple of lenses, but when I'm toting a lot of gear, the shoulder strap digs in and the weight makes my back ache by the end of the day.

I prefer photo backpacks for longer trips or anytime I carry super telephoto lenses. A photo backpack distributes the weight across the shoulders, back, and hips; provides plenty of pockets; and makes it easy to find your gear. Also, the more you look like a backpacker, the more likely that thieves may suspect your pack contains dirty socks rather than valuable camera gear.

Traveling by air. As carry-on restrictions become more stringent each year, traveling with photography gear becomes more trying. When

I first flew to Africa, the airlines allowed me to carry on all my photography gear (not counting a tripod) and a bag of film the size of a basketball. Digital photography doesn't require the basketball anymore, but computers and storage devices pose new challenges.

I carry on everything fragile. This includes zoom lenses, my primary camera body, all memory cards, and anything with a hard disk, for instance, a digital wallet or a laptop computer. Fixed lenses, tripods, backup bodies, and so on go into hard-case luggage. It's wise to disguise an obvious photo case by putting it in a box, but regular suitcases do a good job and don't attract attention. I wrap the gear in my clothes to protect it from the gentle attentions of baggage handlers.

Make sure to lock luggage after the security staff scans it. Transportation Security Administration (TSA) staff carry master keys that open certain approved locks. They will open your locked case and relock it when they finish inspection. Luggage retailers stock TSA-approved locks.

Backpacking. A different set of issues confront the digital photographer who leaves the grid and sets out afoot. When backpacking, weight is the enemy. Canny compromises shed the most weight while maintaining the greatest possible flexibility in the field.

Bring an ultralight tripod. It may be a bit rickety, but hanging something heavy from it, such as a camera pack or a food bag, adds stability. Carbon-fiber tripods minimize vibration, don't conduct the cold, and are lighter than metal equivalents, albeit at a premium price.

Although professional camera bodies deliver the highest resolution, they are heavy. Consider bringing a lighter, more fragile, lowerresolution body on longer hikes. I leave my 11 megapixel Canon 1Ds at home and bring the much lighter 6 megapixel Digital Rebel. Not only is the body lighter, but it runs on featherweight batteries, too.

To counter the reduction in file size, I create wide-angle shots by stitching together two or three adjacent vertical images using a longer focal length lens. The composite gives me the same angle of view as a wide angle but more than doubles the file size and therefore the resolution. On a rock climb when every ounce counts, 8 megapixel point-and-shoots produce acceptable results while weighing about a pound total.

When I carry a single-lens reflex body, I bring one zoom lens. I like something in the 24mm–70mm range. Instead of carrying a special macro lens, I add a close-up lens, a magnifying filter that permits tight focusing. Not only is it lighter than a macro lens or an extension tube, but a close-up lens suffers no light falloff and thus requires no exposure compensation.

Bringing Extra Batteries

Good luck finding an outlet for your battery charger in the wild. Carry more than enough batteries to last the entire trip. When calculating your battery needs, remember that cold conditions reduce battery life. Solar chargers are nifty, but they add weight and drain the wallet.

Protecting Your Gear

Sometimes it seems as though the natural world is bent on destroying photographic equipment. Rain, snow, dust, and wind-borne sand work their way onto and into cameras and lenses. Don't count on camera bags to protect them.

For travel in really wet environments, such as rafting, sailing, or hiking in the tropics, put your delicate gear in dry bags; these are found at kayak and canoe dealers. For less-soggy conditions, large resealable plastic bags suffice; they also work just as well in dusty conditions. I always carry extras.

When preparing to shoot in rainy or dusty situations, protect the camera and lenses with a resealable plastic bag and some rubber bands. Cut the zipper off the bag and slit the bottom of the bag. You now have a plastic tube. Place the camera in the tube and wrap a rubber band around the lens near the front. Make sure the plastic doesn't interfere with the lens. Use an ultraviolet (UV) filter to seal the lens. If the viewfinder protrudes from the body, gather enough plastic to cover it, cut a hole for the viewfinder, and fasten the plastic with another rubber band. For very long telephoto lenses, make a tube with a larger garbage bag.

When changing smaller lenses, use a film-changing bag to block dust. Keep the end caps on the lenses until just before you affix them to the camera body. Compared to loading film in a medium-format camera blind, swapping lenses is a snap.

In some conditions, no matter how fast you swap lenses, dust will make its way inside. Imagine shooting on Kenya's Amboseli Plain; the least wind kicks up a fine dust from the dry lake bed. In such nasty conditions, I bring a separate camera body for each lens I intend to use on a given day. For example, in Amboseli I put my primary body on my 500mm lens and a 70mm–200mm zoom lens on my backup camera. This presupposes that you carry a backup and can live with only two lenses over the course of the day.

Some cameras seem to attract dust more than others. A lot of unproven notions are out there, all unsupported by evidence. Some people believe charge-coupled device (CCD) sensors attract more dust than Complimentary Metal Oxide Semiconductor (CMOS) sensors; other people swear you must turn off the camera so the sensor isn't charged while exposed to the open air. Others insist the movement of the mirror during "motor drive" shooting stirs up dust inside the camera, causing dust to adhere to the sensor glass. Who knows?

Keeping Clean

After shooting, dry your gear or blow off dust before storing it. I try to take dust in stride. If I can see a few small spots after air cleaning, I usually decide to deal with the problem later in Photoshop using the Clone tool or Healing Brush. If things get really vile, let a technician clean the camera when you get home. The technician is likely to remove dust inside the body destined for your sensor.

Cleaning the sensor. If you shoot a digital camera with interchangeable lenses, sooner rather than later you'll notice motes on your images: the effect of dust on your sensor. Frequent, obsessive cleaning is a fact of life with digital SLR cameras. Sensor cleaning gladdens the hearts of obsessives, but I find it the most annoying part of digital photography. Fixed-lens cameras deny dust entry to the chamber, so their sensors remain clean. A curse on all of you (and your progeny) with fixed-lens consumer or prosumer cameras who needn't deal with dust on the sensor.

The dust doesn't accumulate on the sensor proper. A glass cover or filter protects the sensor from damage and dust. This glass can be scratched, smudged, or otherwise degraded, and the first rule of cleaning is "Do no harm."

Sensor cleaning tools, left to right: bulb air blower, swabs, cleaning fluid

When you're ready to start cleaning, find a brightly lit work space. Make sure the battery is charged or plug the camera into an electrical outlet. If a camera loses power while you are cleaning the sensor, you will need to take it to a repair shop. Activate the cleaning protocol in your camera. This will open the shutter and swing the mirror out of the way, giving you access to the sensor surface. Remove the lens and hold the camera so the opening faces down. This may reduce the amount of dust landing on the sensor glass as you clean it.

Before touching the sensor glass with anything, try blasting it with air. Don't blow into the camera. The safest method involves a handsqueezed blower bulb. It's hard to get enough force with small bulbs, so look for one that fills your whole hand. Move the nozzle of the blower into the camera, taking care to avoid touching the glass with the nozzle. Squeeze vigorously a few times. After a visual inspection (a jeweler's loupe can help), replace the lens.

The easiest way to check for dust after cleaning is to shoot a frame of blue sky or any other absolutely uniform bright or midtoned subject. Turn off the autofocus and throw the lens out of focus manually. After downloading the image, bring it up on your computer screen and enlarge it up to 100 percent. Look for dark flecks and globs on the screen. If any dust remains on the sensor, it will be easy to see.

Some photographers use compressed carbon dioxide (CO_2) gas rather than squeeze bulbs. Ordinary compressed air, which contains propellants that accumulate on the sensor surface, must be avoided; CO_2 cartridges designed for air rifles contain additives that may cause problems, too. Regular CO_2 cartridges produce a very strong stream of air; although CO_2 gets the dust moving, it can also force it into inaccessible parts of the camera. Another disadvantage is that CO_2 cartridges are not welcome on airplanes these days.

If air cleaning fails after a few tries, use swabs and cleaning liquid. With my lack of dexterity and inability to apply just the right amount of cleaning fluid, I end up with streaks that take many frustrating minutes to eradicate. Sensor Swabs™ minimize streaking. Shaped like miniature white brooms, these swabs allow for precise application of cleaning solution. Each swab can be used twice. Sweep in one direction, which should cover half the sensor, and then sweep in the other direction with the other side of the swab so that both halves of the sensor receive one swipe. Larger sensors require two swabs. Sensor Swabs are pricey gizmos; use them only when air cleaning fails.

Don't forget to give your electrical contacts a blast of air when you're done with the sensor. You don't want the connection with a computer to fail during downloading. Every now and then, treat the

TAKING DIGITAL PHOTOGRAPHS

contacts with an anti-oxidizing contact cleaner. These can be found at high-end hi-fi stores.

Storing and Archiving

Disasters could befall a film photographer, but with a moment's inattention or the failure to back up data, a digital photographer can lose hours, days, or weeks of work. Film can overcook in the back of a car or fall into a creek, but nothing compares to your only digital wallet crashing midtrip with only a few memory cards in reserve.

Take to heart Firesign Theater's Department of Redundancy Department. Back up your backups. Download your images to a digital wallet and back those up on a notebook hard drive. Burns CDs of your best images while on the road. Storage media vary in capacity, stability, convenience, and reliability; only CDs or DVDs are reasonably stable.

These habits will save you sooner rather than later.

Opposite: The tinted walls of Grand Canyon of the Yellowstone consist of layered volcanic rock.

• 84 •

The Digital Darkroom

4

hotographers have always manipulated their images to achieve the effects they desire, either to replicate the scene they photographed with maximum accuracy or to craft a new or more glamorous vision. Ansel Adams underexposed and overdeveloped negatives and then dodged and burned

while printing to bring his signature dramatic tonality to life. Modern film photographers use supersaturated Fuji Velvia and other pumpedup emulsions to add punch to their images. Although their photos are not "accurate," they convey a better sense of being out there than films with more natural color palettes. Polarizers, warming filters, and other tools shift color, too.

Most color film photographers hand their exposed film to a lab, which produces the finished product, either a slide or a color negative. Few practice color printing. Black-and-white photographers are more likely to control everything from exposure to printing. They learn the intricacies of film development, print exposure, and printing, as well as the vagaries of chemicals, light, and photographic papers.

Digital photography gives the photographer even more power and control without exposing you to toxic chemicals or sentencing you to hours spent in a dark, cramped room. Mistakes are immediately corrected with an Undo command. Many people already own most of the components of a digital darkroom: a computer and a color printer. All that's left is learning how to use them to work with digital images.

COMPUTER AND PERIPHERALS

Unlike the war between VHS and Beta videotapes, the conflict between PC and Macintosh computer platforms still rages. Because Photoshop and all other major photo-editing programs work on both platforms, and both offer comparable speed, choose based on your preference or experience. If you use a PC or a Mac at home or work, stay with it. Learning the software is tough enough without compounding the difficulty by using an unfamiliar operating system. If you work with an older operating system, upgrade to the latest version; some software and peripherals require the newest updates. If you are new to computers and know someone who will help you get oriented, go with the system that person prefers. Hands-on help will prove more valuable than the hottest hardware.

Computer

Get the fastest computer you can afford. Operational speed is largely a function of processor speed and the amount of available memory. The processors on new machines are plenty quick, so concentrate on installing as much memory as you can so the machine can handle large files without slowing to a crawl. With too little random-access memory (RAM), the computer is forced to write and read from the hard disk, which is frustratingly slow. You can't be too thin or too rich or have too much RAM.

You will need at least five times the RAM of the largest file you create. For example, if you want to stitch together four pictures of 30 megabytes each, the calculation would be: 4 images of 30 megabytes each = $120 \times 5 = 600$ megabytes. In this case, you will need more than half a gigabyte (500 megabytes) of RAM.

Make sure the computer has either FireWire (IEEE 1394) or USB-2 ports—or both. These are the fastest ports, which is critical when transferring large amounts of data. These ports connect to printers, outboard hard drives, cameras, and memory cards with specialized cables and card readers. Downloading a full 2-gigabyte memory card takes minutes with USB-2 but almost half an hour with USB.

Hard Drives

Get at least two large hard drives. A few hundred large files add up quickly. The main drive will contain programs and the images you wish to access quickly. If this drive approaches capacity, the computer will lose speed. Archive on the second disk and use it as a scratch disk, a region of memory the computer uses while performing other functions on the primary drive. If the primary disk crashes, your image files will be unaffected if archived on the backup drive.

CD Burner

Because all hard drives fail eventually, back up both your hard drives with CDs or DVDs. CD burners are inexpensive, and individual CDs are less than \$1 each. A CD can hold more than 600 megabytes. DVDs store 4.4 gigabytes of information on each disk. They are rated at 4.7 gigabytes but can write only 4.4. However, a format war is being waged in DVD media, and DVDs seem more sensitive to scratching. You may want to wait for the market to shake out before committing to DVD.

Monitor

Get the largest, highest-quality monitor possible. If the monitor lacks resolution or color fidelity, you will not be able to tell when color is off, and the resulting file will suffer. Currently, cathode-ray tubes (CRTs) generally surpass flat LCD screens in both color and resolution. However, a few high-end LCDs now equal or exceed the best CRTs. Choose a high-quality video card. Most are designed for 3-D

gaming applications. Look for a card with a high rating for 2-D graphics and a lot of memory.

If you use Adobe Photoshop, its menus will clutter the screen. You can move the menus to a second monitor if your video card and operating system allow it. There is no need for high quality for a second monitor used to view these menus. Use an older monitor or buy a cheap, small-footprint flat-screen LCD. It's also possible to "hide" the menus until needed in most programs.

You will need to calibrate the monitor (and the printer; see below) to reflect the exact color the computer produces (see Color Management). Instructions for approximating ideal monitor calibration can be found in most comprehensive Photoshop books, but for precise settings, a third-party calibration kit including a sensor attaching to the screen produces optimal calibration.

Printer

Selecting a printer depends on your goals. If you want gallery-quality prints, a high-resolution, large-format inkjet printer using archival ink is the way to go. A professional stock photographer can get by with a smaller printer employing less-expensive ink because the end product is the file itself, not a print of it. This type of photographer uses prints to produce thumbnails or reference prints to help clients and agencies decide which file they want for their project or collection.

Scanner

If you have a collection of images on film, you may need a film scanner. The scans of these film images will serve as a new slide collection so obtain the highest-quality scanner possible. Fortunately, prices have fallen dramatically in recent years. Nikon and Minolta manufacture excellent units at modest prices. Imacons deliver drum-scanner quality (almost) at a fraction of drum prices but still cost five or ten times as much as Nikon or Minolta's best scanners. True drum scanners cost a Midas ton and require bathing slides in oil before scanning.

EDITING PROGRAMS

The market is full of alternatives. Whichever editing program you choose, you will enjoy orders of magnitude more control over your images compared to struggling with film and chemicals.

Adobe Photoshop and Elements

Photoshop by Adobe is the king of photography editing programs, but new users must suffer through a steep learning curve. It offers multiple ways of accomplishing any given task. For example, many different tools can select parts of an image for editing, each with its own strength.

Adobe's stripped-down version of Photoshop, Elements II, has everything most photographers need for a fraction of Photoshop's price. Plus, its menu-driven commands and concentration on photographic needs simplify operation at a small cost in flexibility. Photoshop is replete with vector and text tools that beginning digital photographers won't miss in Elements II. Even professionals can ignore many Photoshop tools. Elements II serves as a good introduction to Photoshop, and its files conform to Photoshop's industry standard. However, for the aspiring professional, the benefits of Photoshop's flexibility and refinement may offset the difficulty of mastering it.

Other Programs

A host of photo-editing programs exist outside the Adobe family. Microsoft's Picture It performs simple enhancements and cataloguing. Picture Window Pro from Digital Light and Color (only for PCs using Windows) offers a simple and powerful alternative to Photoshop for about \$100.

COLOR MANAGEMENT

Volumes have been written about color management and the perils that await anyone who shirks its mastery. The primary concerns of color management consist of choosing a color space and calibrating the computer monitor.

Color Space

Programmers define color spaces—specific ranges of colors that necessarily omit some colors found in nature—to accommodate the limitations of computer monitors and printers. In Photoshop, the default color space is sRGB IEC 61966-2.1 (RGB = red, green, blue, the colors used in television and computer monitors to simulate the full color spectrum). This color space was originally designed to avoid overtaxing the limitations of older color monitors. CMYK is the color space used by the printing industry (CMYK = cyan, magenta, yellow, and black—the four colors used to create four-color printing). The color space demanded by photo agencies is Adobe RGB (1998).

Before you do anything else, change the default on your computer by pressing Shift-Control-K (on a Mac: Shift-Command-K) to open the color settings menu. Under Working Spaces, select Adobe RGB. Now you can work in the largest available color space. Switching to another color space will result in circumscribing the gradations of color available.

THE DIGITAL DARKROOM

Because the monitor provides the first and best view of your digital files, accurate calibration of it is essential. There are two ways to achieve this: using Adobe Gamma in Photoshop or employing a device that reads color directly from the screen. Before starting either process, set your background screen color. Go to Display (on a PC) or Appearance (on a Mac) in the operating system. Select gray, because brighter border colors distort the way we perceive hues on the screen.

Using Adobe Gamma. Place the monitor in a dark area, and let it warm up for a half hour or so. Find Adobe Gamma in the Control Panel folder of the operating system. A series of menus walks you through the calibration process.

Reading directly from the screen. For optimal calibration, obtain a device that reads color directly from the screen. The device sticks to the screen with suction cups or hangs in front of it. Software menus lead you step by step to create a color profile. Expect to pay a couple hundred dollars for "perfection."

Opposite: Courthouse Towers, in Arches National Park

ork flow for slide film is a simple matter: take the picture, get the roll developed, then edit, label, and file the slides. The order of tasks is self-evident and relatively quick. Work flow for digital photographers is full of opportunities, choices, and pitfalls because you control

every step of the process, from exposure to print. Establishing a sequence of tasks to master the work flow yields the best possible results and reduces the chance for missteps such as losing or damaging an image.

Everyone needn't follow the same steps. Goals differ. Shortcuts that satisfy amateurs may prove disastrous for professionals. For most photographers, only a few images per day truly deserve the most fastidious repair or color and contrast optimization. As you work with digital files, you can decide which compromises work for you.

	TIP: WORK-FLOW CHECKLIST
	e this checklist or equivalent next to your computer. Refe
	until these steps become automatic. If you do, you'll save
your	self extra effort and dodge the occasional disaster.
1.	Capture images.
2.	Transfer and save images.
3.	Edit.
4.	Convert from RAW.
5.	Rotate and crop.
6.	Resize up.
7.	Correct color and contrast.
8.	Repair.
9.	Enhance.
10.	Save working file.
11.	Sharpen.
12.	Save archival file.
13.	File.
14.	Output.

WORK FLOW IN DEPTH

The work-flow sequence described in this chapter meets the needs of a professional or passionate amateur. You may wish to rearrange the order. Whatever you decide, follow the same steps each time.

Capture Images

Shoot the picture, following the procedures outlined in Chapter 3, Taking Digital Photographs.

Transfer and Save Images

Your images are at risk until you save them to a computer, external hard drive, or CD. Do so as soon as possible. Always back up all your images in their original format. Memory cards and CDs are cheap compared to losing irreplaceable images.

Edit

Once your images reside in a safe place, rank them and toss out the losers. Editing is the grunt work of photography. It's no fun squinting at dozens of similar images trying to decide what to keep and what to toss, and deleting is always painful. But editing frees the computer's memory—and your time, ultimately.

The latest versions of Windows and Macintosh OS X include rudimentary image-organizing capabilities: Photo Wizards in Windows XP, iPhoto on the Macintosh platform. They satisfy the demands of small collections. For more power, programs such as Extensis Portfolio and ACDSee (and many others) offer extensive key wording and searching capabilities as well as rudimentary image-enhancement capabilities. Photoshop 7 introduced the File Browser, a program for organizing and viewing large collections of images, and Photoshop CS bolstered the power of the File Browser considerably.

All image-management programs create thumbnails of the images and permit scrolling through the thumbnails for rapid review and editing. Ideally, preview the entire image at a glance and zoom in to check clarity. People with great self-discipline and courage can delete image by image on the spot. I prefer to rank the images.

Sorting systems. I use three sorting categories: Select, Maybe, and Trash. Some images jump out as Selects; others cry out for the digital round file and get the name Trash. I delete the trash as soon as possible to prevent myself from agonizing over losers a second time. Most images fall between those extremes, so I put them in the Maybe file. (Any names will do, as long as you understand them.) When editing the Maybe file, I ask myself whether I would ever send this image to a client or a friend. Because I usually have a better version in the Select file, Maybes usually move to Trash for disposal. Anything I would willingly publish, I keep (unless I have plenty of similar images), and images I like for sentimental reasons go in a Personal file, separated from the primary collection.

When editing a shoot, try to emulate Genghis Khan on a grumpy day. Images with bad exposure, with unintentional lack of sharpness, or that caught the wrong moment (the cat's eyes are shut, for example) deserve instant extirpation. Nothing makes a digital image collection unmanageable faster than folders cluttered with useless pictures.

After cleaning out the Maybe file, delete the Trash. Don't bother performing further adjustments to the surviving Maybes until you have a use for them.

As time passes, your collection of digital photographs will multiply. If you don't edit ferociously and create an organized system for storing keepers, it will metastasize.

Naming and filing systems. Map out your naming and filing system first, then create appropriate folders in the image-management software before naming and storing your files. For example, decide in advance if you want to connect places and people, say, rock climbers in Yosemite. These photographs could be filed under "California: Yosemite: climbers" or under "people: athletes: climbers: rock: Yosemite." Creating your own personal Dewey Decimal system for images is a large task, but you can make the world conform to your preferences, at least in this arena. Stay consistent after you decide how to categorize your pictures.

Most digital cameras assign an alphanumeric code to each picture. These are the titles you see when you download these pictures into a folder. File Browser and most of the other image-management systems provide for batch renaming. You can assign a name that works in your system, and the software will assign it to the list of photographs followed by a number; for example, Yosemite climber 122.

Convert from RAW

If you shoot RAW files, perform as much color and contrast control as possible in the RAW editor.

Rotate and Crop

Rotate and crop the keepers for easier manipulation later. Distracting elements such as leaves or branches often intrude along the edges of an image. Excise them so you won't waste time retouching parts of the image you will discard later.

Cropping. Removing any distracting extraneous elements around the edges of the image with the Crop tool takes just a few moments. Activate the Crop tool on the toolbar. Place the cursor where you want to establish a corner. Depress the mouse button (left-click on a PC) and drag the cursor to the opposite corner, creating a rectangle of "marching ants." Release the mouse. The area outside the marching ants will turn black. Adjust the size and shape of the frame by grabbing the small boxes on the new frame and dragging them to the desired location. Once you are satisfied, go to the Image menu and click Crop or press Control-A (on a Mac: Command-A).

WORK FLOW IN DEPTH

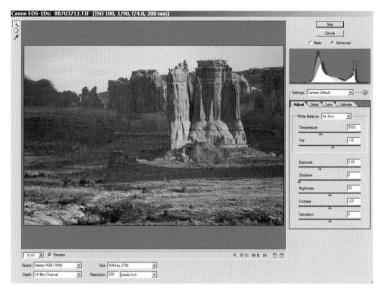

The RAW file editor provides a host of reversible adjustments to enhance an image.

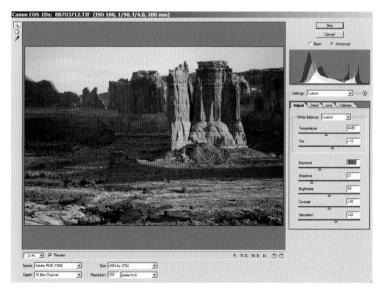

Adjusting Exposure, Shadow, Temperature, and Saturation endows the image with the color and contrast of a saturated slide film.

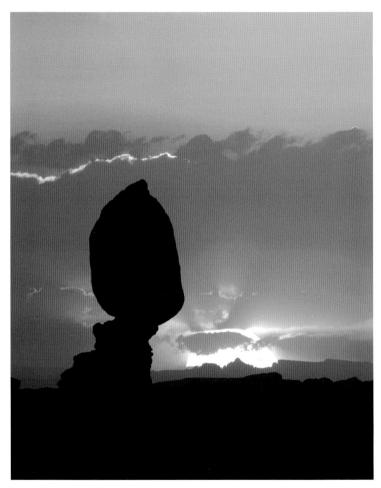

Cropping a horizontal photo can create a strong vertical composition.

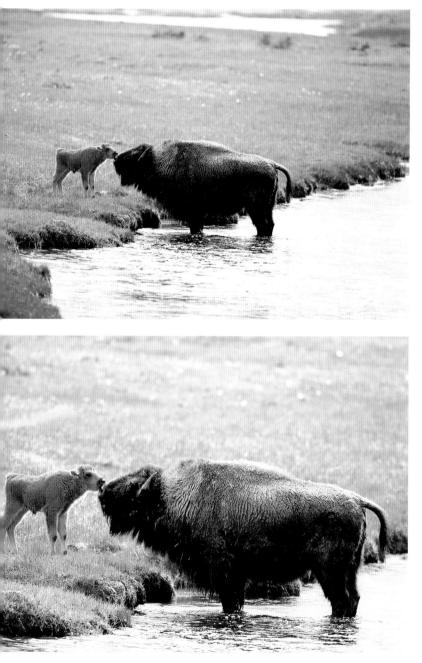

Cropping can also focus attention on the primary subjects.

WORK FLOW

Cropping can create new compositions. You may find a vertical composition hiding in your horizontal image. Cut it out with the cropping tool and save it under a unique name. You lose some resolution, but you may be able to resize upward without resolution loss (see below).

Cropping can extend the range of your telephoto lens. If I can't fill the frame with my subject in the field, I can reduce the size of the frame in the computer to get the image I wanted in the first place: a tighter telephoto.

Straightening the horizon. Everybody does it. You try to grab a shot without a tripod, but when you review your pictures, the horizon looks tilted in some of them. This is a simple fix in Photoshop.

Select the Measure from the Photoshop toolbox. Click on the Eyedropper tool and hold it so the fly-out menu appears with the Measure tool on the bottom. Drag the Measure tool along the horizon from side to side. If you look at the options bar, a number defines how far this angle deviates from zero.

Select Rotate Canvas from the Image menu. Select Arbitrary to bring out a dialog box. Photoshop automatically enters the degree off-center and corrects it when you click OK. As the program tilts the image to correct the horizon, the image tilts within the canvas. Then use the Crop tool on the toolbar to trim it down to a perfect rectangle.

Resize Up

When the original file is not large enough for a given end use, such as meeting the file-size requirements of a stock-photo agency or providing enough pixels for a very large print, increase the size of the file now. You can inflate the image to the desired size either with tools in Photoshop or with plug-ins. To make the image smaller (for example, for the Web), wait until you've completed the other corrections so you can keep a larger corrected file as an archival copy.

With Photoshop. Image Size in the Image menu instructs the program to interpolate to any desired size. However, large increases produce unpleasant, noticeable artifacts, especially pixelization. Repeatedly increasing the image size in 10-percent increments (called stair-stepping) suppresses these artifacts, but the process is tedious. You can write an Action in Photoshop, a macro that will execute a given set of commands, to automate the process.

With plug-ins. A number of plug-ins and actions perform the

Opposite: The stare of a large wild animal catches attention.

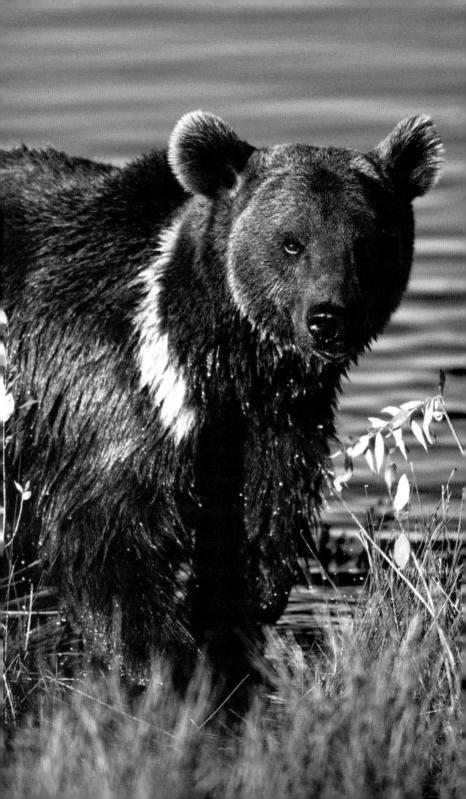

same service automatically, often with additional steps to keep the image sharp. I use Fred Miranda's plug-in, which now resides in the Automate folder of the File menu.

Correct Color and Contrast

Almost every image requires some degree of contrast and color correction. It's easy for things to go wrong between capturing an image and printing it. Almost infinite color adjustments can occur every step of the way, from the settings on the camera to the calibration of the monitor to the settings on the printer. Correct color in Photoshop by using tools with the most control. For example, Levels and Curves do a better job of tonal and contrast control than Brightness/Contrast and Hue/Saturation, without limiting future adjustments. Try Levels, Curves, and the automated tools in the Image menu to decide which you like the best.

Photoshop allows you to fiddle with color correction in many ways. It bristles with options and parallel ways to achieve similar results. You may find techniques you prefer. Wander through the menu as an experiment; as long as you have an archived copy of the image, you have

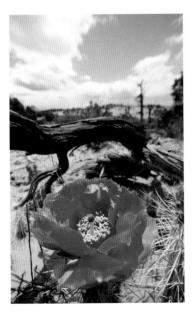

This image lacks saturation and contrast.

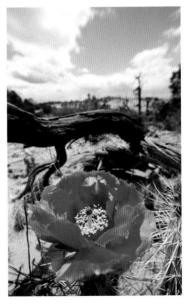

The corrected image is more pleasing and accurate after adjusting levels.

nothing to fear. The Undo command is the most powerful learning tool in Photoshop.

Using Auto Color. Photoshop, Elements II, and most other editing programs provide for automated color and contrast correction. For quick and dirty correction, use Auto Levels, Auto Color, and Auto Contrast under Adjustments in the Image menu. These tools can improve the look of an image quickly; however, a glance at the histogram shows that they throw out pixels as they do their work, and sometimes the image looks worse.

With Auto Color, you let Photoshop do the work. Click on Auto Color under Adjustments in the Image pull-down menu. Auto Color adjusts shadows, midtones, and highlights. If you are unsatisfied with its efforts, go to the Edit menu and click on Fade Auto Color. A dialog box with a slider labeled Opacity will allow you to reduce the effect of Auto Color, which may improve the result.

TIP: VARIATIONS FOR QUICK COLOR CORRECTION

Variations (found under Adjustments in the Image pull-down menu) produces multiple images with differing color casts and densities for a given image. You can select one to apply those corrections to your image or just to get an idea of how you want the final product to look after making adjustments in Levels. Variations will generate new sets of multiple corrections based on several variables if you click on one of them.

Using Curves. For your best shots, optimize color with Curves. After opening the digital file, click Adjustments in the Image pulldown menu and choose Curves. You will see a graph with a diagonal line. Bend the line into a gentle S by dragging the upper quarter slightly up and the lower quarter slightly down.

The graphs in Curves adjust color intensities. You can drag the curve for each RGB (red, green, blue) color or for all at once. Try dragging the left-hand third down a bit and the right-hand third up to create a gentle S curve. This produces a better color balance most of the time.

Using the Eyedropper tool. For ultimate control, use the Eyedropper tool instead. Double-click on the left-hand Eyedropper in the lower right of the Curves dialog box. This Eyedropper controls shadow color. A Color Picker menu appears that allows you to assign values to each of the RGB (red, green, blue) colors. Assign a value of 20 to each color, which is a neutral setting, and click OK.

WORK FLOW

Before adjustment, the RGB graph in Curves looks flat and so, probably, does the image it represents.

Using the Threshold tool. When you can't eyeball highlights or shadows, the Threshold tool in the Adjustment Layer pop-up menu can find them for you. Click OK to exit the Curves dialog box. This saves the defaults you established earlier. Open the Layers palette and click the Adjustment Layer icon, a half black/half white circle. When the menu opens, click Threshold to bring out its menu. A simple histogram will appear.

To set the shadow points, drag the slider under the histogram all the way to the left so the image becomes pure white. Then slowly drag the slider back toward the middle until the first bits of black appear. This is the darkest part of the image. Close the dialog box by clicking OK, which creates a new layer.

To set the threshold for the darkest part of the image, click and hold the Eyedropper tool in the toolbox and select the Color Sampler tool. If the dark area you wish to select is small, increase the magnification of the

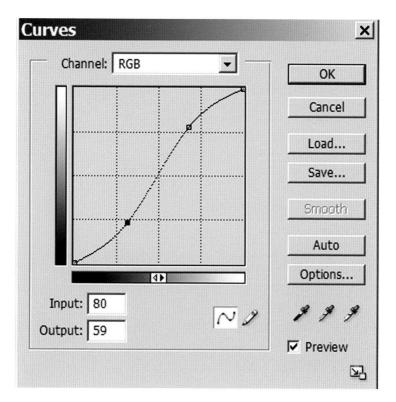

Dragging shadows down and highlights up to create a gentle S curve usually improves color and contrast.

image; otherwise, you may accidentally mix light and dark pixels. Place the Color Sampler over the darkest part of the image and click. A small mark with the number one on the image indicates where you sampled. The Info menu will appear to give you the value of that point, but since the information is not important at the moment, close that menu.

Return to Threshold Adjustment Layer by double-clicking the half black circle again. When the Threshold dialog box appears, drag the slider all the way to the right so the image becomes completely black. Then slowly drag the slider to the left until the first white appears. This is the brightest part of your image. Again, click OK and use the Color Sampler tool to establish the brightest value in the picture. Number two will appear on the image at that point, denoting the highlight.

With highlights and shadows established, you can delete the Threshold Adjustment Layer. Open the Layer's palette and drag the Adjustment Layer into the trash. The image will look the way it did initially, with the addition of the highlight and shadow markings.

Reopen the Curves dialog with Control-M (on the Mac: Command-M). Click on the Eyedropper found at the bottom of the Curves dialog box. With the Eyedropper, click directly on the mark next to number one on your image. This corrects the shadow area. If the image does not look better, you either didn't click exactly on the mark or your initial sample was corrupted with too many bright pixels. If this happens, click Undo and try again.

To finish correcting the highlight area, select the Highlight Eyedropper, the farthest right in the Curves dialog box. Click on the second mark to establish the highlight.

While Threshold provides a mechanical way to determine shadow and highlights, establishing the midtone is a matter of taste and judgment. Click on the middle Eyedropper to select the midtone. Look for a neutral gray or color equivalent in the image and click on it. The change may be dramatic or subtle. Experiment. Use Undo if you don't care for the results. If the image contains no midtones, skip this step.

Before closing Curves, click on the curve where it crosses the middle line and drag it slightly higher. This will brighten the midtones a bit and bring out a little more detail. When you find a value you like, click OK in the Curves dialog box to apply your corrections to the image. Remove the highlight and shadow markers by opening the Options bar and clicking Clear. Save the image with a name that lets you know you performed color and contrast correction.

Compare the corrected image with the original. Ideally, the colors will have more snap, the shadows will look richer yet have more detail, and the contrast will not exceed the capacity of the camera.

Using Levels. For quicker adjustments, use Levels. To adjust shadows and highlights, choose Levels under Adjustments in the Image menu. You'll see a histogram. At the bottom of the histogram are three Input Level sliders: Shadows on the left, Midtones in the middle, and Highlights on the right. Usually there will be flat areas on either side of the peaks and valleys of the histogram. Click on the Shadow slider and drag it to the right to where the histogram first begins to rise. Then drag the Highlight slider left to the place where the histogram rises. You have defined the white point and the black point, the brightest and darkest pixels. The levels between the black point and the white point are redistributed to increase the tonal range and thus the overall contrast of the image. You can set the black and white points in Levels with Eyedropper tools if you prefer.

TIP: THE EYEDROPPER

Eventually you will use the Eyedropper tool to select color in an image. The Eyedropper tool looks at a single pixel in its default setting, called Point Sample. A single pixel is fine if you're selecting from a pure blue sky, but many objects that appear to be a single color are composed of many different tints. A piece of granite that appears as off-white contains white quartz, black biotite, and pink feldspar. A more accurate selection averages all of these colors instead of picking just one.

To change the Eyedropper's sample size, go to Sample Size in the Options menu and select 3 by 3 Average. Most of the time, this sample size contains enough information for an accurate average.

Next, double-click on the right-hand Eyedropper. This controls highlights. Enter a value of 240 for each color, also a neutral setting, and click OK.

Repeat this process for the middle Eyedropper, which controls midtones. The neutral value for midtones is 128.

With these values in place, you're ready to use the Eyedropper tools to perform most of your color correction. It's easy. Just click the appropriate Eyedropper on the part of the image that corresponds to it. For example, select the shadow Eyedropper, find something black in your image, and select it. Repeat the process with the highlight Eyedropper by finding a brilliant white highlight and clicking on it. The midtone Eyedropper can be tricky since it takes experience to recognize the color equivalent of 18 percent gray. (Hint: Green grass and clear blue skies are midtones equivalent to about 18 percent gray.) Some images have no midtones at all.

Repair

Photoshop and other programs offer multiple ways to remove flaws such as signs of dust, glare, moiré patterns, and other artifacts—from an image. Sensor dust and glare on the subject are common problems with easy fixes. For small flaws, try the Clone tool or the Healing Brush, both found in the Tool menu.

Using the Clone tool. This copies a circle from another part of the image and replaces the flawed area with the copy. After activating the Clone tool, adjust the brush size so it is a little larger than the area you want to replace. Move the Clone tool cursor to the area you want to copy (a clean area near the flaw), hold down the Alt key (on the Mac: Option key), and click the mouse. Move the cursor to the area

The Healing Brush or Clone tool samples clean sky before pasting over an adjacent dust spot.

you wish to replace. You will see a mark indicating the area you sampled that will be copied. The relative position of source and target will remain constant until you redefine it with the Alt or Option key. Now you can click the area you wish to fix. The Clone tool pastes the copy over the flaw. You can use the tool like a brush. Drag it across the damaged area and it will apply the fix over the area. Make sure the source doesn't stray into an area you don't wish to copy.

Using the Healing Brush. This operates the same way but with a different effect. It blends adjoining areas together. It can generate well-modulated transitions or inadvertently infuse unwanted tones in the repair area. If you don't care for an effect, undo the operation by clicking a box in the History palette before the last operaton.

Using the Patch tool. Try this for larger areas. It hides under the Healing Brush on the Tool palette. Click on the Healing Brush and hold for a moment. A fly-out menu will appear with the Color Replacement tool and the Patch tool. Clicking the Patch tool activates a cursor. The cursor acts like the Lasso selection tool. After confirming that the Option bar is set to Source, drag the cursor around the area you wish to repair.

Opposite: Wind blows Upper Yosemite Falls toward me. Mist on the lens caught sunlight, creating flare that I could remove with any number of tools, including the Clone tool and the Healing Brush.

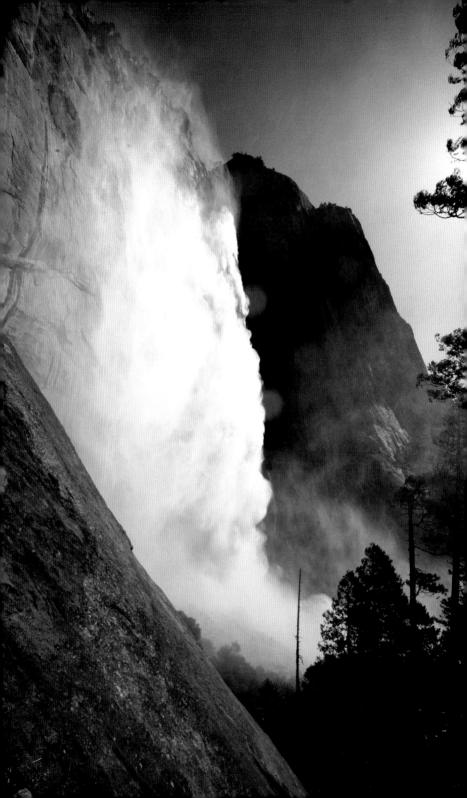

WORK FLOW

When you release the cursor, "marching ants" will define the area. Move the cursor to the middle of the selected area and drag the selection to an area you wish to copy. As you move the selection boundaries to the area you want to copy, you will see the original selection still outlined with marching ants. When you release the mouse button, the program places a copy of the new selection over the original selection. Press Control-D (on the Mac: Command-D) to deselect the repaired area and turn off the marching ants. The repair is complete.

Enhance

Those who wish to improve on reality should do it now. This is the time to perform magic. Change the color of a tent, remove a distracting log, or give a hiker a haircut if that pleases you. Turn color images into warm sepia duotones or dramatic infrareds. Paste in a new sky. Add motion streaks to a running animal.

Photoshop contains a plethora of filters. Most mimic an artistic

The orange gradient in Nik Color Efex Pro 2 rescued this image by adding color to a drab shot.

effect such as brush strokes, but a few are workhorses for outdoor photographers. Photoshop CS's color-correcting filters can be used to remedy unwanted color casts or to add a desirable hue to a drab image.

Nik Color Efex Pro 2's set of plug-ins offer an array of color gradients, toning tools, and focus effects that can replace hours of computer work with a click of a mouse. Remember to experiment with the Fade command after applying a filter. When a filter acts too strongly, the Fade command backs off the effect so the change looks more natural. More isn't always better.

Save Working File

Save the results thus far—in 16-bit, if possible—before you sharpen. Sharpening cannot be undone after the file is saved. Retaining an archival copy may prove vital.

Sharpen

The more you work on an image, the softer it becomes, so sharpening should be the last thing you do. Additionally, you never want to sharpen more than once because artifacts will multiply. Too much sharpening results in a harsh, almost grainy photograph. In an oversharpened photograph, both contrast and noise seem to increase. If you sharpen early in the process, additional operations could soften the image later on.

Don't bother trying to sharpen low-resolution images. They are inherently highly pixelated, and even modest sharpening will highlight the individual pixels. Apply as little sharpening as possible. It's helpful to know what the final output will be in order to judge the amount of sharpening required. A larger print requires more than a smaller print. Most photo agencies want to receive unsharpened images. Unless instructed otherwise by an agency, perform minimal sharpening only when numerous operations soften the picture.

There are a number of ways to sharpen, but Photoshop's confusingly named Unsharp Mask is the most common tool for the job. Several sharpening plug-ins apply sophisticated algorithms that sharpen without introducing artifacts. Currently, the most popular are Nik Sharpener Pro and Photokit Sharpener.

Although the application of Unsharp Mask (the least intuitive name ever) is the standard method of sharpening in Photoshop, it is far from the best. With even modest sharpening, it tends to generate halos and other artifacts around sharpened pixels. There is a method with fewer problems: luminosity sharpening. Here's how it works.

Luminosity sharpening. After opening your image, go to the Filter menu and select Sharpen. Choose Unsharp Mask and apply the

WORK FLOW

filter. Set the amount to 85 percent, the radius to one, and the threshold to four. Consider this a starting point. Experiment with different settings for softer subjects, such as people or flowers, as opposed to more sharply defined images, such as buildings and spires.

Click OK to activate the Unsharp Mask filter. Go to the Edit menu and select Fade Unsharp Mask. The Fade dialog box will appear. Instead of clicking Normal in the pop-up Mode menu, click Luminosity and then OK. Clicking OK applies sharpening to just luminosity, not color, which allows you to boost sharpening while creating fewer unwanted artifacts.

Save Archival File

Copy the file to a folder in your image-management system. This is your archival copy. Toss the working copy if you wish, unless you can imagine an eventual need for an unsharpened version.

File Output

Putting images on the Web or sending via email. Large files bog down the Web. A 30-megabyte TIFF file can take minutes to load. Because resolution on the Web is low, it makes sense to send compressed files. For email, convert your images to 72 dots-per-inch (dpi) JPEGs set at low or medium quality. This way, you won't fill up your recipients' mailboxes and drive them crazy while they wait for your attachments to show up on the screen. The same resolution works for illustrations on websites as well.

Printing images. Instead of going to a photo finisher, today's digital photographer can print everything from wallet-sized pictures to 11-inch x 17-inch prints on an inexpensive consumer printer. The rapid evolution of inkjet printer quality, coupled with falling prices of these printers, is one benefit of the digital revolution. Inkjet quality merits comparison with the best conventional printing processes. The latest archival inks last from decades to more than a century without significant fading. The printing wizards found in editing programs allow quick and easy setting changes for print size, paper type, and resolution. With the advent of Plug and Play, installing a new printer requires just connecting a cable. The bad old days of fabricating custom cables and flipping pins on the printer so it can communicate with a computer are history.

Print from the File menu in Photoshop. I prefer to use the Preview option. Seeing a thumbnail in the canvas reminds me to switch from landscape orientation (horizontal) to portrait orientation (vertical) if necessary. If I need to switch, I click Page Setup to go to the toggle. Provisions for changing paper size and format reside here, too.

Check the Scale to Fit Media box so the image covers the paper. Click Print. Another Print dialog box appears, which lists printer names and provides the option of printing multiple copies. Click the Properties box to set print quality and paper type. Once satisfied, click OK to print.

Printers boast ever larger dots per inch (dpi) specifications. These large dpi numbers are largely meaningless. Feed your printer 300 dpi files for best results. This keeps file size down without loss of apparent quality.

Opposite: The Torres del Paine in Chilean Patagonia

Advanced Techniques

fter you have optimized color and inherent contrast for a single image, the fun begins. The digital darkroom offers limitless opportunities. You can replicate every photographic technique in history or forge new ones. You can mimic the effects of specialty cameras or create unimagined views of

this world or any you can imagine. You can combine the best from several exposures of a scene or assemble a montage. This chapter concentrates on techniques most useful for a photographer who wants to keep at least one toe in reality but who doesn't feel constrained by precedent.

SELECTIONS AND LAYERS

Much of the power of the digital darkroom resides in the implementation of selections and layers. They are central to a host of operations from advanced color adjustment to elaborate montages. Unfortunately, proficiency demands facility with dozens of tools and an understanding of how computers look at photographic images. These tools and their applications require in-depth reading; see Resources for suggestions.

Whenever you want to modify, move, save, or delete part of an image, you must select it, but first you must select the selection tool. In Photoshop you can employ lassos, magnetic lassos that cling to edges, rectangular marques, extractors, and magic wands. You can select a color range or employ any number of masking techniques. Sundry

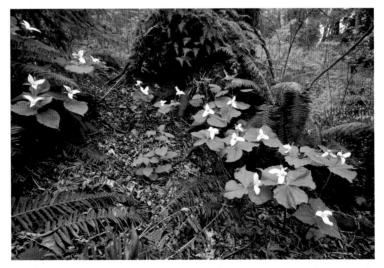

I removed pink fringing on the edges of the white trillium flowers with the Chromatic Aberration tool in the RAW editor.

plug-ins such as Knockout automate the process, but they have their own learning curves.

Figuring out how to make a clean and believable selection and place it in a new milieu is one of the toughest tasks facing an aspiring Photoshop wizard. You need to select enough materials without including unwanted pixels from the source image. Insubstantial components such as hair or smoke pose significant challenges.

A hard-edged selection tends to look fake. Soften the edges by "feathering," a scalable range of randomization that mutes the hard edge. "Fringing" occurs when bits of color from the original background attach to the selection. Erase fringing by picking a brush, selecting the color of the selection, and painting over the unwanted color at about 50 percent opacity. (The lowered opacity looks more natural.) If some unwanted color remains, brush over it again. Lowered opacity allows you to build up the correct color. If things go wrong, go to the History Palette to undo mistakes. Then try again.

When you want to insert a picture of yourself in a fetching bathing suit standing atop Mount Everest, use layers. The concept is simple. Layers are like transparent film. You add bits and pieces of images and stack them to create a single image. In practice, learning the power of layers takes a significant investment in time. You can use layers to introduce new elements to an image, alter color, add masks, and erase unwanted parts. You can save groups of layers for later use. Since each layer is an image unto itself, a stack of layers can gobble a lot of storage space quickly.

EXPANDING DYNAMIC RANGE

Because both slide film and most digital systems suffer from compressed dynamic range—five to six stops compared with ten stops for the human eye—photographers struggle with contrast control. These media can capture detail in the shadows or the highlights but not both at the same time. Shooting toward a sunset is an egregious example. The correct exposure for the bright sky will leave the foreground unacceptably dark, whereas exposing for the foreground will make the sky too pale.

Over the years, photographers have marshaled several techniques to moderate the problem. Graduated neutral-density filters can compensate for several stops of excessive contrast. Usually these filters are rectangular, clear at one end and gradually becoming increasingly gray at the other. (Round models place the transition in the middle, usually the last place where a horizon looks good.) They impart no color. The photographer moves the filter in front of the lens until the transition lines up with the horizon. A spiky horizon defeats the filter because dark areas extending into the bright region will be rendered even darker.

With a dark subject close to the camera—for example, a climber silhouetted against a sunset—fill flash will bring out detail without blowing out the sky. Fill works best when used judiciously. If the foreground subject is as bright as the background, it often looks artificial. Set the flash one or one and a half stops underexposed for a natural effect. For another way to use fill flash, see Digital Fill Flash.

Darkroom techniques enhance contrast. Flashing the print before exposure reduces excessive contrast. A contrast mask, a black-andwhite negative placed over the original transparency, mutes the bright areas. Burning and dodging, manually altering the exposure of the print by blocking light during exposure, will bring out dark areas and subdue bright ones.

We can surpass the efficacy of these techniques in the digital darkroom without inhaling chemicals in a dark cramped room.

Digital Blending

Digital blending controls contrast precisely, applying correction only where needed. By comparison, a gradient or graduated neutral-density filter is a blunt instrument. A single tall tree or a line of statues on Easter Island will defeat a gradient, whereas digital blending allows for brightening the tree or statue while darkening the sky.

It requires at least two exposures and sometimes three. Shoot one to capture highlights and another for shadow detail. If neither one does a good job with midtones, shoot a third exposure. Usually autobracketing no more than a stop and a half on either side of average creates three usable exposures.

Each image must be identical in composition and focus to the other. Use a tripod to make sure. Don't change the focus or the aperture between shots because depth of field will shift.

There are a number of ways to blend two images. Use the exposure with the smallest properly exposed area as the background layer. Create a duplicate layer of that exposure. Open another exposure over it. Erase the poorly exposed portions of the new top layer to uncover the properly exposed image below. Repeat the process with a third exposure if needed.

Various complex masking techniques achieve even better results, and several plug-ins automate the process, including Fred Miranda's DR1 Pro and Optipix 2.0 by Reindeer Graphics (*www.reindeergraphics.com*), which also includes sharpening and noise-reducing features.

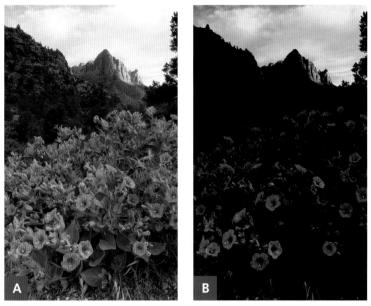

The Watchman is one of the most-photographed formations in Zion National Park. To add interest to the composition, I opted for a wideangle lens and a very low point of view. This resulted in a new center

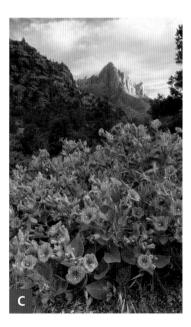

of interest (the flowers) while blocking a distracting bicycle trail and adding color. However, contrast between sky and foreground exceeded the dynamic range of the sensor. A. I exposed for the flowers in the first shot. B. The second shot captured the sky properly. I opened the darker image as a background layer, created a duplicate layer, and opened the brighter shot as the top layer. C. Finally, I erased the overexposed sky to reveal the clouds from the dark layer. After flattening the image (collapsing two layers into one), I gave the resulting image a new name and saved it.

Digital Fill Flash

Fill flash is a valuable tool for reducing contrast, but in the real world, it is often impossible to employ. An ordinary flash doesn't have enough power to brighten subjects photographed at a distance with a long lens. In wildlife photography, we often don't have time to put a flash on the camera before the animal takes off. Even with people photography, getting the flash on a camera in time can be problematic. Imagine fiddling with a flash while dangling from a rope on a cliff trying to shoot climbers moving from sun to shade and back.

In Photoshop, we can mimic the effect of fill flash. After opening the photo, click on Adjustments in the Image menu and select Levels. Drag the center Input Level slider to the left until the primary subject is exposed correctly. If this is insufficient, increase the highlights with the right-hand slider. The background will likely appear overexposed, but don't worry. Choose History in the Window menu. The History palette will appear. History records the last 20 operations. In this case, the History palette will show two operations, Open and Levels.

Click on Open. This will reverse the tonal adjustments you made earlier. Now click on the icon to the left of levels in the History palette. You're now ready to "paint" the brighter image on the original dark one.

Select the History Brush from the Toolbox (a paintbrush icon on the right side of the Toolbox). Go to the Options bar and select a softedged brush from the Brush Picker. Paint over dark areas needing brightening, and take care to avoid touching the background, which would create an unwelcome overexposure. If the subject appears too bright, reduce the opacity to mute the effect. If the subject still appears excessively bright when you're done, go to the Edit menu and choose the Fade History Brush to lower the opacity as needed.

COLOR TEMPERATURE FILTERS

Photoshop CS includes a new set of photo filters for color correction. These include the warming filters 85, 81a, and 81b as well as the cooling filter 80. The warming filters block blue; the cooling filter blocks yellow and orange tints.

To activate the filters, click the Create Adjustment Layer icon at the bottom of the Layers palette. The icon is half black and half white. Choose the filter you want in the pop-up list and click OK. You can modulate the effect of each filter by moving the density slider in the photo filter pop-up menu.

Although you can create the same effects with the white balance settings in the RAW editor, when an image has been converted to JPEG or TIFF, these filters do an adequate job. With multiple digital solutions in our quiver, there is no longer any need to carry color correction filters in the field.

MIMICKING VIEW CAMERA MOVEMENTS

View cameras enjoy a number of advantages, among them the ability to tilt and shift the film plane and lens board. These movements allow the photographer to correct parallax and increase depth of field. Some of the technical excellence of Ansel Adams can be attributed to his mastery of tilts and shifts. With digital photography, you can apply these effects in the digital darkroom.

Digital Shifts: Parallax Control

Parallax is a fancy word for perspective. An object close to us looks bigger than it would farther away. While this seems normal when we photograph a landscape stretching into the distance, it causes distortion in the vertical plane if we tilt the camera. If you take a picture of a picket fence straight on, you will see a series of parallel lines. If you lie on the ground and point the camera up at the fence, the pickets will look wide at the bottom and narrow at the top. Furthermore, instead of remaining parallel, the lines converge. The same distortion occurs when you tilt a camera up to photograph a forest or a ridge of high mountain peaks.

You can counteract parallax distortion by moving the film plane so

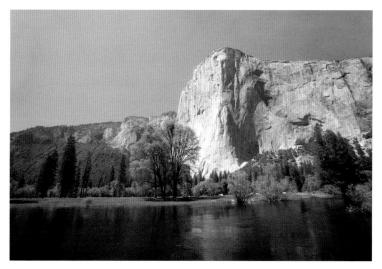

The trees lean toward the center of the frame when the wide-angle lens points up. A shift lens or Photoshop tools could correct it.

ADVANCED TECHNIQUES

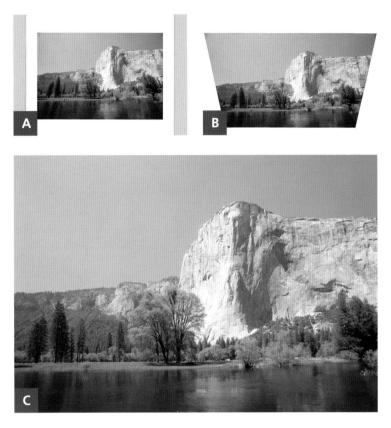

A. If you are planning to correct this parallax distortion in the computer, include extra space to allow for cropping in Canvas Size under the Image pull-down menu. B. After opening Free Transform, click and drag the "handles" outward until the trees return to vertical. C. Crop the image to create an appropriate rectangular frame.

it becomes parallel to the subject. However, in practice this can prove impossible. The only way to get the film plane parallel to nearby tall trees would be to climb halfway to the top of a neighboring tree. (If you can get far enough away, you could use a longer lens that will let you to keep the film plane—or, in the digital case, sensor plane parallel with the subject.)

The shift movements found on view cameras and on some specialized lenses for 35mm camera systems keep the camera body parallel to the subject as the front of the lens shifts upward to capture the top of the subject. While this technique solves the problem, the lenses are expensive and heavy, and you would need several of them to cover various focal lengths.

In the digital darkroom, you can stretch the top of the image like taffy and restore the parallel lines—in other words, parallax—at your convenience. The computer doesn't know you want to mimic a view camera shift, so it doesn't automatically adjust the proportions the eye expects between near and far. To look natural, images require both these adjustments.

After opening the image you want to correct, increase Canvas Size (found in the Image menu) so you have room to work. Then use Select All on the Edit menu or press Control-A (on the Mac: Command-A) before pressing Control-T (on the Mac: Command-T) to initiate the Free Transform tool. There will be a small point in the middle of the picture. Grab it and drag it down to the bottom of the image so it touches another point midway between the two vertical edges.

Hold down the Control key (on the Mac: Control Command key), click on the "handles" at each upper corner, and drag them to each side, which will stretch the upper part of the image. Play with these adjustments until everything looks as if it's lined up properly. If you're not sure which way is up, open the ruler by pressing Control-R (on the Mac: Command-R). You can drag the vertical ruler to your tree or mountain to make sure it's properly aligned.

After these corrections, the subjects will look vertical, but they may appear top-heavy or too thick. Drag the top edge of the image up, which will stretch the subjects and make them look thinner. If things still don't look right, find Distort on the Filter menu and choose Pinch. Move the Amounts slider until objects in the image look normal. Usually a few percentage points are all you need.

Digital Tilts: Increasing Depth of Field

A view camera can enlarge depth of field by tilting the front or the back of the camera so it becomes parallel with the plane of the subject. You can mimic this effect by blending depths of field digitally. Combine the in-focus elements of two or more images, creating a single image with everything in focus. This is useful when you need a faster shutter speed to freeze the foreground. For example, flowers in a breeze will transform themselves into brush strokes at f/22 at 1/4 second but stand crisply at attention at f/2.8 at 1/250 second. Because f/2.8 delivers a very shallow depth of field, the trick consists of bringing the rest of the image into focus.

First, take two shots. Shoot the background layer at a very small aperture, focused either at infinity or at hyperfocal distance. Hyperfocal

distance is the focal distance for any given f-stop where the foreground comes into focus closest to the lens without losing sharpness at infinity. This distance changes with aperture. The smaller the aperture, the closer the hyperfocal focus point. Some lenses feature hyperfocal distance markings. Align the infinity marking with the aperture marking to get the widest range of focus at that aperture that still includes infinity. When you look through the viewfinder, you won't see the range of focus unless your camera has an aperture preview setting to stop down the lens. Cameras default to the widest aperture to let the most light into the viewfinder. After stopping down the lens manually, you will notice that f/16 looks very dark. However, once your eyes get used to the darker view, you can visually confirm exactly how much of the image is in focus. Pocket-size hyperfocal distance charts are available to guide you. Some cameras allow you to mark the nearest and farthest areas you want in focus electronically. Then they set both focus and aperture automatically.

Shoot the second shot for optimal sharpness of the foreground. Open this image as a layer atop the background. Reduce opacity so you can see both images simultaneously. Then use an eraser tool to remove the out-of-focus parts of the second image, revealing the sharp background image. Flatten the image and save it as a new file. You will have a range of focus beyond the reach of most film cameras.

TIP: DEPTH OF FIELD

The focal length of a lens combined with its aperture determines depth of field, the range of focus. Shorter focal length and smaller apertures increase depth of field, independently or in concert. For any given lens, f/16 produces a greater area in focus than f/2.8, a very wide aperture. Focal length affects depth of field even more. At f/4, a 500mm telephoto lens focused on a nearby object will exhibit only a few inches in focus, whereas at the same aperture, a 14mm super wide-angle set on infinity will show the whole scene in focus except for a few feet of foreground.

BLACK AND WHITE

Photoshop converts color images to black and white in a single click in the Image menu. Click on Desaturate to create a black-and-white version of the color picture. However, this operation usually generates a drab result. Fortunately, Photoshop possesses many tools for enhancing black-and-white images. Some are tricky and laborious, but others

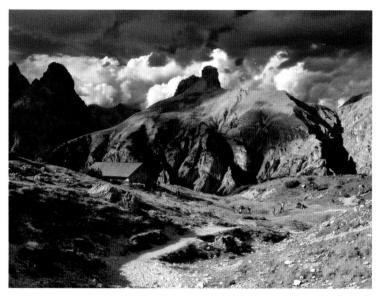

I converted this image of Italy's Dolomite Mountains from color to infrared black-and-white with a third-party plug-in. The same effect could be achieved in Photoshop by desaturating the image, increasing contrast with Curves, and applying a judicious amount of Gaussian blur.

yield 90 percent of the results for 10 percent of the effort. This section looks at the easy ways to create satisfying results.

Photoshop gives the photographer multiple ways to bring black and white to life. You can tweak the Desaturate command by manipulating contrast. The Lightness Channel in Lab Color performs a serviceable job. You can use Calculations in the Image menu, which will gratify your friends and dismay your enemies because there is nothing intuitive about it. Since Calculations offers no significant advantages, we will draw a veil over it.

I favor the Channel Mixer on the Adjustment Layers pop-up menu because the settings act like color filters in film-based black-and-white photography. By adjusting each RGB (red, green, and blue) channel, we can dial in the correct tonality.

Open your image and choose Channel Mixer in Adjustment Layers, found at the bottom of the Layers palette or in the Layers pulldown menu. When the menu appears, click the Monochrome box to convert the image to grayscale (black and white). Each of the three sliders alters the percentages of each color and works independently. Experiment with the sliders until you produce a pleasing image. The sum of the percentages of the three sliders shouldn't exceed 100 percent if you want an accurate black-and-white image.

For a dramatic image with wide tonality in the tradition of Ansel Adams, break the 100 percent rule. Move the blue slider left as far as possible. By blocking blue so it converts to black, the Mixer mimics a dark red filter. Set the green slider as far right as possible and then back it off until a little detail shows up. Drag the red slider to +160. With the optimal subject matter (for example, blue sky, puffy clouds, snowy mountains), the picture should look contrasty and rich. Experiment with the slider settings until satisfied. Lighten or darken with the Constant slider. Click OK. You can save the image and work on it later or flatten it before saving the finished product.

There are many black-and-white conversion plug-ins on the market, but it's easy enough to create black-and-white images on your own. It's also possible to produce black-and-white infrared images. This involves modifying a high-contrast black-and-white picture by applying Gaussian blur and adding noise to serve as grain. In this case, an inexpensive plug-in can save time and effort.

You can desaturate and boost contrast in a RAW editor as well. Set Saturation to zero, adjust Exposure, and boost Shadow to taste.

DIGITAL PANORAMAS

Our eyes don't view the world vertically or horizontally; we see panoramas. Heretofore, photographing panoramas required either special equipment or manipulation of the negative or slide. Medium-format 6cm x 17cm cameras such as the Fuji or the Linhof cost many thousands of dollars for a body and a few lenses but produced stunning results; 35mm cameras with the same aspect ratio could deliver panoramas with modest resolution.

Digital photography allows us to stitch together adjacent images to create a high-resolution panorama with our existing lenses and digital camera. As an added advantage, each element of the panorama adds information and increases the file size and thus the resolution of the finished print.

Thus, you can effectively increase the resolution of a low-resolution camera by stitching together three verticals side by side to create a single horizontal image. This image will have three times the resolution of a single horizontal image shot with that camera. I use this trick when I want to carry my lower-resolution (and much lighter) camera on a hike instead of my brick-heavy main camera body.

If you want to create a true panorama, which is at least twice as wide as a wide-angle shot, stitch two horizontal pictures. You can also stitch together a series of verticals; however, the file size of your final image becomes quite large and cumbersome, especially in uncompressed formats. Large files are ideal only for very large prints.

Shooting for a Panorama

Creating the raw materials needed for effective stitching demands care and luck while shooting. Some examples: On a windy day, the branches of trees waving in the wind won't line up properly where two images meet. A horizontal panorama that covers a large area of sky shot with polarizers can vignette ferociously and require some tinkering in an editing program to blend the blue. If people or animals walk through the shot, they may show up twice in the same panorama; they can often be cut out in Photoshop or a similar program, but the efficient photographer will avoid such a problem in-camera while shooting.

Shoot in manual mode. Program, aperture priority, and shutter priority often change exposure from frame to frame, which makes blending the images more difficult.

If you shoot in RAW format, make sure you apply identical settings in the RAW editor. Most editors have provisions for applying the same settings from the previous image to the next or to batch-edit a group of pictures.

The major editing programs all offer tools for creating panoramas, and a number of plug-ins exist to automate the process. As usual, Photoshop provides several methods for stitching pictures together. Photomerge performs many steps automatically and will yield good results if you take care while capturing the image.

First, make sure the edges of each picture—at least 15 percent of each image—overlap. This will give the program enough common points to align the images correctly.

Second, use a tripod. While it's possible to create a panorama of a series of handheld images, swiveling the camera using the horizontal movement of the tripod head will produce the most common points in adjacent images, which helps Photoshop or another program align the images and also will give you more usable space. When hand-holding, you tend to move the camera vertically, creating areas that will have to be cropped out to create the final rectangle. Using a tripod also yields a larger file—in other words, more information.

Using Photomerge

Load the images into Photoshop and convert them into TIFF or Photoshop format. (Many of the plug-ins only work with 8-bit files. Go to Mode in the Image menu to change the files from 16-bit to 8-bit.)

Panoramas: I stitched this wide-angle panorama of Angkor Wat in Photoshop from the four telephoto images shown below, overlapping from one image to the next. I tinted the finished image to make it resemble a 100-year-old hand-tinted postcard.

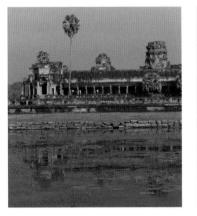

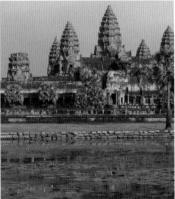

Choose Automate in the File menu and select Photomerge. You can also reach Photomerge in the File Browser under Automate. This saves steps; you can select the pictures and open Photomerge at the same time.

The Photomerge dialog box opens and provides two ways to select the images for the panorama: either by automatically selecting previously opened images or by allowing you to select photos or folders. Check the box in the lower left corner so Photomerge will automatically assemble your panorama. Once you've selected the images, click OK. If you shot with enough overlap, Photomerge displays the new panorama. If it looks good, click OK again. The panorama will open it as a flattened image that you can save. Use the Crop tool to trim extraneous material.

Sometimes Photomerge has trouble lining up the images. When that happens, a dialog box opens and announces that you have more work to do. Click OK. Photomerge then displays the part of the panorama that it could construct in the main window while relegating the parts that confused it to a light box above.

Check the Snap to Image box in the lower right-hand corner before setting to work. Then drag one of the pictures from the light box down to the image under construction. Align it as closely as possible before releasing the mouse button. Photomerge will then blend them together if enough overlap is present.

Using Plug-ins

A number of Photoshop-compatible plug-ins exist for constructing panoramas, including Real Viz Stitcher, Pano Weaver, 3DVista Studio, and many others, all with differing strengths and weaknesses. I sometimes prefer Panorama Maker over Photomerge when variations in the tonality of the sky require significant blending.

Building a Panorama from Scratch

Sometimes the Photomerge action in Photoshop and the plug-ins can't assemble the panorama correctly. When tweaking the final image in Photoshop won't solve the problem, building the panorama from scratch is the answer.

Open the left-hand image. Then go to Canvas Size in the Image menu to add enough width to accommodate all the pictures. Check the Relative box in the menu and click the left-center box of the anchor grid. The canvas will expand to the right of the first image to allow room for the panorama to grow. Open a layer for each additional image, leaving adequate overlap.

When melding one image with another, lower the opacity of the top layer by 50 percent so you can see both images at the same time to align the pixels. Once you have it aligned, bring the opacity back to 100 percent. Repeat as you add pictures to the panorama. Flatten the resulting image and enjoy your new panorama.

DIGITAL STAR TRAILS

A two-hour star-trail shot on digital will suffer from excessive noise. We can minimize the noise by taking 120 one-minute exposures and stacking them as layers. The addition of one black layer further suppresses noise.

Shooting Star Trails

Snapping a shot a minute manually for two hours is tedious when major camera manufacturers offer combination timer/cable releases. Set the timer for shutter speed and the aggregate length of time (or number of exposures that equal that time), so as little time as possible elapses between exposures; otherwise, gaps will appear in the star trails. Set the camera to Bulb. Place the camera on a tripod and focus manually; the autofocus on some cameras becomes confused by shooting stars. Turn off sharpening filters in the camera, which can create unwelcome artifacts. Make sure your batteries are charged. Since digital cameras gobble power, especially when the mercury dips, use a separate battery pack if available. Because you will take 120 shots, install a memory card that can accommodate that much data.

Pay attention to foreground and the compass. Star trails in isolation have no context or impact. Silhouettes of cacti, trees, or pinnacles anchor the image. You can "paint" the foreground with a flashlight or a flash to add detail and interest. Cover the light with a colored gel for an otherworldly effect (or wait to do that in Photoshop). If you include the North Star, the other stars will wheel around it.

Take one shot with the lens cap on. You will use this file, a digital dark slide, to reduce noise.

Assembing the Photograph

After transferring all the image files to the computer, it's time to assemble the photograph.

Open the first file in the sequence. Save it under the name you want for your finished image. Open the second image. Use Select All and then Copy it from the Edit menu. Then Paste the copy onto the first image and close the second image.

Select the new layer from the Layers palette. Open the Blended Mode menu on the palette and click on the Lighten mode. The two images blend into one. Repeat for each successive image. You can create a macro, called an "action" in Photoshop, to automate the steps. Consult Help or a manual for instruction on actions.

As the number of layers grows, they occupy computer memory. Flatten all the layers periodically to keep the computer running quickly and to prevent "insufficient memory" warnings.

As the number of images in the stack grows and the resultant star trails lengthen, the advantages of digital long exposures become apparent. With film, long exposures accumulate light scattered throughout the atmosphere. This reduces the contrast between star and background. The Lighten mode in Photoshop selects the brightness pixel from each layer but doesn't add them together. Thus, dark sky remains dark and bright objects get no brighter than they appear on the brightest layer. This means that a foreground won't blow out even if it receives repeated exposure from a full moon, headlights, or some other source.

Opposite: Bison cross a river in Yellowstone National Park.

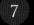

A Digital Approach to Subjects

photographer needs to understand which techniques work best for each subject. A sharp shot of a moving athlete necessitates different shutter speeds, depth-of-field decisions, color temperatures, and so on than a landscape with a strong foreground element. Equipping yourself with a set of pre-

cepts for commonly shot subjects enhances your chances for creating technically proficient images.

THE ENVIRONMENT

Certain situations present consistent challenges and opportunities. Rules of thumb tailored to a subject give us a starting point when we consider how to create the best image.

Water

Water covers 70 percent of the planet. Unless we don scuba gear, we photograph only its surface, but we should learn to do it well.

Motionless water reflects its surroundings. It adopts the blue of a clear sky or the leaden gray of a dark, cloudy day. It mirrors the surrounding landscape, albeit less brightly. (Use a graduated neutral-density filter to bring tonalities in line.) Often, lowering the angle of view to just above the waterline affords the best view of a reflection.

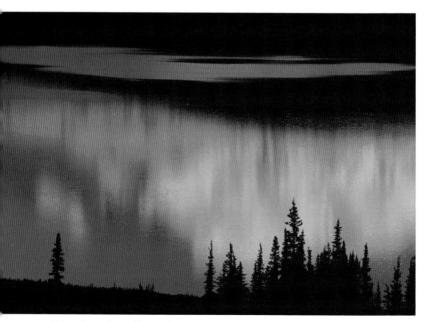

Wonder Lake reflects the sunset on Denali, in Alaska.

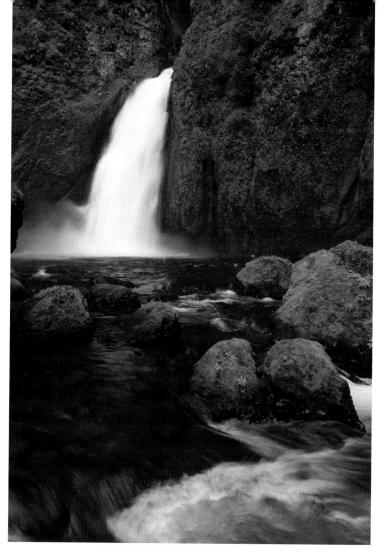

Long exposures of large waterfalls, such as this image of Tanner Falls, Columbia Gorge, can blow out detail in the water.

Capturing the dynamism of a waterfall demands the correct selection of shutter speed. A little blurring augments the sense of movement. Too little blur results in a static, crystalline effect, whereas too much obscures shape and internal shadows. The correct shutter speed varies with distance. Shooting a cascade a few feet away could work with 1/250 second, but that shutter speed would turn a distant cascade to glass. Experiment to find the ratio of shutter speed to distance to create the effect you prefer.

Low-volume waterfalls and moving streams acquire a painterly

A DIGITAL APPROACH TO SUBJECTS

effect with long exposures. They don't turn into an undifferentiated white, the fate of a furious cascade shot at a slow speed.

Deserts

Deserts are landscapes stripped of extraneous elements. We find strong designs in rock laid bare. The plants and animals living in these harsh environments develop unusual forms and behaviors, and they stand out in the austere environment. Saguaro cactus in the American Southwest or the spiny forests in Madagascar can look as alien as the set of a bad science-fiction movie. Animal adaptations such as the movement of a sidewinder or the hump of a camel signify "desert" as strongly as a sand dune.

Almost all desert photography occurs near sunrise and sunset. The harsh light of midday, which begins early and ends late, creates harsh shadows and bleaches the colors of the rock. However, during magic light, the rock glows. We can see the reds, yellows, and even blues and greens of naked rock. In many areas, these vivid colors complement powerful forms.

Foregrounds are especially important in the desert. They endow a

I found this miniature rock sculpture in Zion National Park as interesting as the park's grand vistas. Sun bouncing off the adjacent wall of red rock enriches the color.

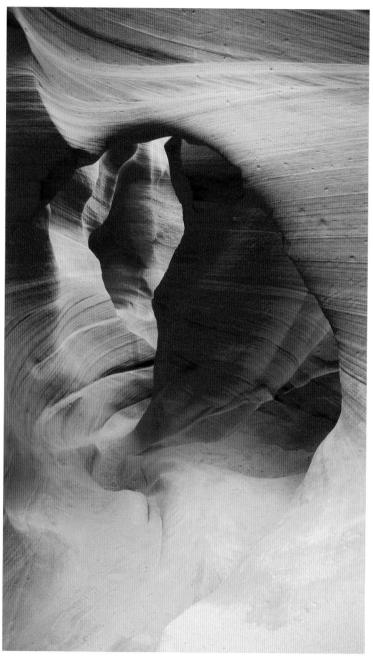

A slot canyon glows with reflected light.

A DIGITAL APPROACH TO SUBJECTS

scene with a sense of depth and break up the uniformity of a monotone scene. Look for a flower, a large puddle for reflections, or an interesting rock. Using a wide-angle lens, try to fill about one-third of your frame with foreground.

Because we shoot most desert photography when the sun is low, polarizers work especially well. They can cut persistent dust in the atmosphere to let a little more blue through, and they boost the color saturation of plants and rock.

The red sandstone found on the Colorado Plateau in the United States presents unique opportunities. Slot canyons carved by flash floods or intermittent streams abound. Some are 100 feet deep, narrowing down to a few feet across. In such constricted canyons, little direct light penetrates to the bottom. However, if the sun hits the upper wall of a slot canyon just right, the light bounces into the canyon, red light illuminating red rock. The effect can be quite dramatic. When shooting a slot canyon, take care to avoid getting any directly lit rock or sky in the photograph unless you intend to blend two exposures together to reduce contrast, one exposure for the rock and the other for the highlights.

Deserts take a toll on camera equipment. Try to keep your gear out of direct sun when it is not in use. If you're driving, cover your camera bag with a coat. In extended periods of brutal heat, consider storing your gear in a cooler as you travel. Dust is a persistent enemy. Switch your lenses quickly. Use compressed air to blast dust away (but not on the sensor!). Keep your gear wrapped up as much as possible.

Mountains

For a landscape photographer, mountains have it all: powerful shapes, vivid colors, clear air. Near the summits, we find restricted color palettes where form dominates. In the highest mountains, winter reigns permanently. In the forests and meadows below the peaks, greens and blues predominate.

Up high, a cooler color temperature prevails. Although we can compensate with filters or by adjusting color temperature in the camera, the blue cast often suits the subject.

The sky adopts a richer blue at higher elevations. A polarizer can easily convert blue to black, so they must be used judiciously. No law says you must use a polarizer at full power. If you want to get rid of glare on a lake without obliterating the sky, twist the ring on the polarizer just enough to minimize the glare.

Finding a good exposure for snow is easy, but determining an ideal exposure can be tricky. Snow isn't pure white. It has a texture, and that texture is represented in grays. Pointing the camera at snow

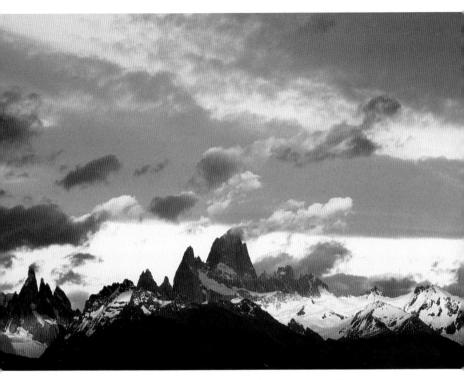

Fitzroy and Cerro Torre appear briefly in the Patagonian dawn.

and overexposing about a stop and a half will produce an acceptable exposure. Average metering produces grayish snow. For an ideal exposure, use the histogram. Take test shots and keep boosting exposure until the histogram starts to rise just left of the right border. This prevents clipping and pulls the highlights down from pure white.

Find ways to lead the eye toward the mountains by using foreground elements such as lakeshores, trails, and fallen trees. Mountains are well suited for verticals and panoramas. Instead of trying to capture everything in a single image, usually a prescription for a muddle, look for compositions embedded in the scene. Try to isolate clusters of strong elements with a long telephoto lens. When a chaos of peaks camouflages a great picture, extract it with big glass.

Don't put the camera away in bad weather. Storms have their own beauty, and some of the most dramatic light occurs as storms break up.

Traveling in the mountains stresses camera gear. It must be protected from heat, cold, dust, and impacts. In the course of a day in the mountains, a pack takes a beating that we would never notice unless

A DIGITAL APPROACH TO SUBJECTS

we remember it contains expensive and delicate camera gear. Camera gear requires its own water-resistant cases inside a pack.

Even in summer, nights in the mountains can be as cold as winter, and the cold saps battery strength. To keep batteries at full strength, place them in your sleeping bag while you sleep or slip them into your pocket as you get ready in the morning. In really cold conditions, place chemical heating packets in the case with your batteries. Sometimes heating a dead battery will bring it back to life.

Caves

Caves honeycomb limestone formations around the world. Water dissolves the rock, and minerals in the water precipitate into fantastic forms. Photographers must contend with low light or absolute darkness, which necessitates the use of flash unless the cave's caretakers installed lighting.

Approach caves with a variety of focal length lenses. Stalagmites, fallen rocks, low ceilings, or confining walkways can limit the range of compositions. A wide-angle lens can encompass a large part of a cave; however, such photographs can look chaotic unless anchored by a strong foreground or large design element. Tilting the camera up while using a wide-angle lens makes tall stalagmites appear to converge. In such cases, make sure there is extra space in the frame. When you get back to your computer, you can use the Free Transform command to straighten the stalagmites.

The variable lighting in a prewired cave can highlight interesting forms such as a cluster of stalactites on the ceiling, which a telephoto lens can isolate. A macro telephoto can capture extremely delicate forms.

If light from the entrance or a hole in the ceiling illuminates the cave dimly, long exposures will work as long as no direct light is in the frame. In prewired caves, you can set the white balance on your camera to deliver an accurate rendering of the rock's color, or you can opt for a color temperature that imbues the rock with a specific hue. For example, a white balance set to daylight (around 5000° K) will add an orange tint. Using the tungsten setting to shoot a cave lit by daylight adds a blue cast.

A single flash is almost useless for illuminating a large cave because of light falloff. If you have several remote flashes you can trigger from your camera, you can set up a shot. With a single flash, frame your shot with the camera on a tripod, set the camera to Bulb, trip the shutter, and walk around with a handheld flash, triggering it by hand to paint the rock with light. Try a few test shots to see how far

Opposite: A long lens isolated these well-lit stalagtites in Carlsbad Caverns.

A DIGITAL APPROACH TO SUBJECTS

from the rock you should stand. If you're too close, your image will be marred by bright spots. Look for opportunities to balance light off the wall to avoid areas of overexposure. Experiment with covering the flash heads with colored gels attached with gaffer's tape to create the effect you desire.

Bring a high-powered flashlight to aid focusing in underlit caves. Caves are damp, so protect your gear from moisture.

Forests

The complexity of forests and their high contrast on sunny days challenges the photographer's ability to create properly exposed, strong compositions. Interlaced branches, heavy underbrush, and the juxtaposition of highlight and shadow bereft of midtones can frustrate our best efforts.

Open spaces created by meadows, ravines, streams, and lakes provide an uncluttered window into the forest. These openings provide opportunities to record conventional views or isolate abstract patterns. A simple row of giant sequoias cropped so we see only vertical reddish trunks can make a strong visual impression where a more expansive view would have little impact.

Once you are in the forest, foregrounds become critical. A bouquet of ferns occupying the lower third of a vertical composition adds muchneeded simplicity. The forest becomes context rather than subject.

There are plenty of macro opportunities in every forest. Tropical rain forests abound with orchids, carnivorous plants, interesting insects, dangling moss, lichen patterns, and bizarre fungi. While less diverse, temperate forests offer analogous opportunities. A hiker enjoying an early-season stroll through the sugar pine forests of the Sierra Nevada could encounter scarlet snow plants, unfurling ferns, and the first round of wildflowers. We tend to shoot macro images as if they were aerial views. If we move our point of view to ground level, we enter a different world.

Obtaining a good exposure while shooting in dense forest is tough. If the sun is out, the range between light and shadow exceeds the capacity of any digital sensor. While it's possible to minimize contrast by taking two exposures with the intent of blending them together to bring up the shadows while muting the highlights in the computer, waiting for overcast conditions will produce even better results. The range between light and dark compresses automatically, and midtones become prominent.

Indirect light reduces the glare on leaves, too. However, even with indirect light, some glare is inevitable, especially if the foliage is wet.

THE ENVIRONMENT

While our brain edits highlights caused by glare, so that we think we see a pure green scene, the camera captures every bright point in the picture. A polarizer cuts through the glare to reveal the underlying colors. I can't imagine photographing in a forest without a polarizer.

Some compositions work inside a dense forest on sunny days. Shafts of light slashing through a redwood forest in light fog or a backlit individual tree are classic subjects. For macro photography, use a reflector to bounce a shaft of light toward your subject or to bring the color temperature back to 5500° K or thereabouts to compensate for

In Yosemite Valley, dogwood blooms in early May.

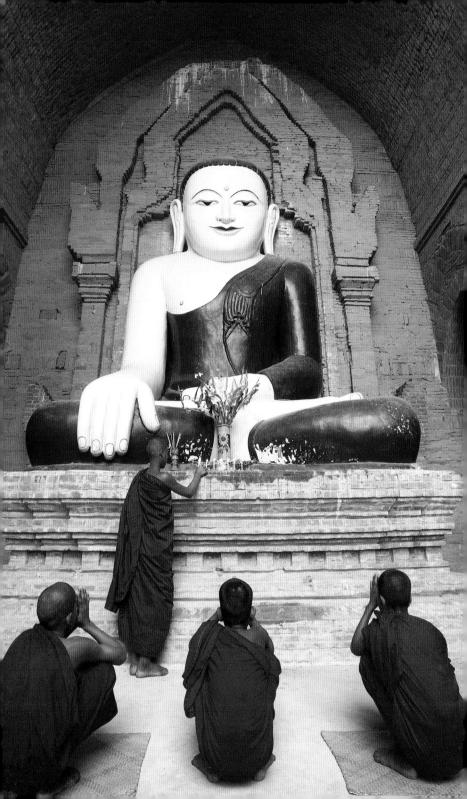

the blue cast that a clear sky reflects on the scene. Use a flash to balance the light on small-scale subjects.

Cities and Ruins

Look for opportunities to symbolize the character of a city. Postcard shots are fine, but better opportunities abound in even the most overphotographed locales. A carnival mask shot in Venice immediately signifies a specific place. Endless photographs of temples, churches, and monuments will send a slide show audience to dreamland; rather than documenting a location, search for images that evoke a sense of the environment. Try to capture action, people being themselves, or characteristic details such as regional food or decoration. Although trying to include too much in an image is a cardinal sin, panoramas provide a fresh view of common scenes. Shoot with parallax correction in mind; in other words, include extra space in the frame to allow for correcting converging lines in the computer.

This bridge near Mandalay is the longest teak bridge in the world.

Opposite: Symmetrical compositions can work in some cases. Praying needn't appear dynamic. Despite the symmetry, the rule of thirds is in play and the heads of the monks direct our attention toward the statue.

WILDLIFE

Digital cameras give a photographer a number of advantages when photographing wildlife but also impose a number of limitations. In some situations, film cameras retain an edge.

Digital cameras' two major advantages are the ability to change ISO settings to accommodate available light and the ability to confirm proper exposure before photographing an animal. When shooting wildlife, we often get one moment to capture magic. If the photographer isn't ready and squanders that moment with poor focus or incorrect exposure, there is no remedy. If 80 percent of photography is showing up, for a wildlife photographer, 80 percent of showing up consists of waiting. This allows plenty of time for anticipating where animals will appear and taking steps to be ready to get the shot when the moment arrives.

Often we work at the edge of the camera's capability. A moving animal in low light comes out soft or blurred at a low ISO. As lighting conditions change throughout the day, we can bump the digital camera's ISO when heavy clouds block the sun and return to a low ISO in bright light. With a film camera, there's no way to optimize film speed for lighting conditions except to guess how light will change during the day. In very low light, we can make a virtue of necessity by blurring moving animals. A moving herd of zebras or a flying flock of geese shot

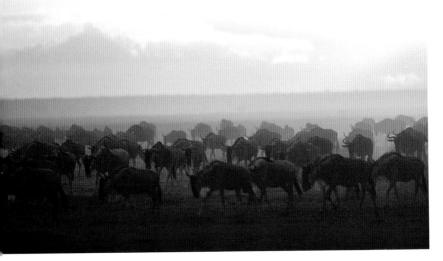

Backlighting from the rising sun and dust kicked up by hooves endows this scene of a herd of wildebeest crossing Kenya's Amboseli Plain with mystery.

We attribute human characteristics to animal faces.

at a slow shutter speed dissolve into brush strokes that convey motion.

Before photographing wildlife, it's wise to take test shots to confirm proper exposure. Once you have the right exposure dialed in, trash the test shots in-camera. If you carry a backup body, attach it to a different focal length lens and set it up in concert with your primary system. Then you can quickly take advantage of different compositional opportunities as the animal moves.

Make sure the eyes are in focus. Our attention gravitates toward the eyes, and if they look soft, the entire image suffers.

Don't photograph animals just one way. A tight portrait can be beautiful, but behavior, context, and detail usually create more interest. Try to anticipate when animals are likely to interact. A baby elephant playing around its mother or a cheetah stalking an oblivious gazelle let us see into the world of the animal as opposed to setting it up on a pedestal. Use shorter focal length lenses so we can see the animal in its environment and get a sense of scale. The principle of "little person, big landscape" applies in wildlife photography as well. Again, this places us in the wild, and the photograph is immediately distinguished from a zoo shot.

If you can get close enough, isolate parts of the animal. The legs and trunk of an elephant divorced from its torso, the pattern of a peacock's tail feathers, or the burning eyes of a cougar force us to look at the animal differently. Look for groups of animals creating patterns. A cluster of flamingos or a herd of bison can become abstract, Escher-like designs.

Chameleons, with their rolling eyes, extensible tongue, and prehensile tail, seem assembled from spare parts. By going in close while ignoring the rest of the animal, I emphasize a single design element.

Although the charismatic megafauna get the most attention, a photographer who seeks out smaller creatures reaps great dividends. A brilliant chameleon in Africa is as wild and strange as a rhinoceros. The face of a praying mantis close up is as terrifying as an alligator. A macro lens opens a strange and colorful world. Don't ignore it.

Digital cameras do have weaknesses when shooting wildlife. First, the shutter lag on consumer cameras can allow the magic moment to disappear. A lot can happen in half a second. Digital SLRs don't suffer from this problem. Second, high-resolution cameras can't shoot as many shots in a few seconds as a good motor drive film-based camera can. Some professional film-based cameras can fire 10 frames per second and burn through a 36-exposure roll in three and a half seconds. If you're photographing a running cat, the more frames you shoot in a short time, the more keepers you'll get. There is no way to anticipate the exact moment for a single great shot. By contrast, my high-resolution digital SLR will shoot about three frames per second. After 10 shots, the camera must pause to process the files. Animals don't wait for us to be ready.

Remember, both for the animals' well-being and our own, that we are visitors to their world. Ideally, don't let the critters know you are there. Stay downwind and try to avoid making excess noise or moving where you can be seen. Causing a disturbance can interrupt hunting or grazing, which potentially can cause harm. With some animals, such as grizzly bears or bison, you may be chastised on the spot for bad manners.

PEOPLE

People like to see people in photographs. Perhaps it allows viewers to imagine they are there, or perhaps seeing images of people in the wild mutes discomfort when contemplating the nonhuman world.

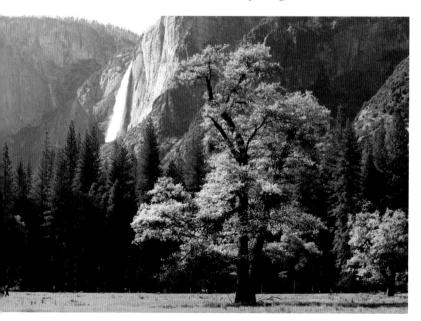

"Small person, large landscape"

When traveling, look for examples of people in their daily lives, such as this rice farmer in Madagascar.

Certainly, photographs with people sell better in advertising and for editorial uses.

Emotional considerations aside, people in photographs help establish scale. "Small person, large landscape" may be a cliché, but that doesn't diminish its effectiveness. It underscores our true position on the planet while allowing the grandeur of nature to take center stage.

People make good foregrounds as well. The head and shoulders of a hiker looking toward the mountains can anchor compositions and direct the eye toward the primary subject. Blurred feet walking along the trail accomplishes the same thing.

An image of people in action changes the emphasis to the people themselves. A mountain biker jumping off a stone ramp, a rock climber lunging for a handhold, or even a backpacker ambling across a meadow shifts attention from background to foreground.

In backlit or dark conditions, fill flash pumps up the impact of people in the picture. Meter for the background and set the flash at minus one or one and a half, just enough to highlight the person and bring up the colors.

As with running animals, blurs are an effective way to convey action.

Experiment to find the correct shutter speed to suggest action without blurring the person excessively. Second curtain flash—flash that fires just before the shutter slaps shut—freezes the subject and leaves a blur behind the subject suggesting motion, the best of both worlds.

Try different angles. Shoot from the ground with a wide-angle lens

A person can walk faster than this temple viper can slither, but it can strike quickly. The blur adds to the sense of menace.

as a hiker walks past, or shoot down on a climber inches from extended fingertips. Try close-ups such as a climber's hands after a rough route or perhaps a mountain biker's shins and feet covered in mud standing in front of bicycle wheels. Only an unexercised imagination restricts the possibilities.

CLOSE-UPS

The closer the subject, the shallower the depth of field. Macro photographers struggle to get everything in focus. Very small subjects such as a lizard's face require the smallest apertures. At the highest magnifications, even the smallest aperture will yield only a narrow range of focus. Make sure the central element of the photograph is in focus. In animal or people photography, concentrate on getting the eyes in focus. Remember that the area in focus will be about the same distance in front of and in back of the center of focus.

If adequate depth of field is not possible in-camera, take several exposures with differing focal points and blend the in-focus elements together on the computer.

Since small apertures go hand in hand with long exposures, flashes are often necessary to prevent the subject's movement from blurring the image. Try to get the flash as close to the subject as possible. This will soften the light and prevent the harsh, specular look of the distant flash. Flash often produces glare a polarizer can minimize.

GLOSSARY

action: A set of instructions equivalent to a macro in a word-processing program. **aperture priority:** An auto-exposure setting in which the aperture remains con-

stant while the shutter speed varies according to light intensity.

artifact: A digitally generated anomaly, such as noise or halos.

average metering: Metering in which all the light in a scene is averaged.

bit: A unit of computer information equivalent to the result of a choice between two alternatives, as *yes* or *no*, *on* or *off*; derived from *binary* digit.

- **bitmapped:** A digital image for which an array of binary data specifies the value of each pixel.
- **bracketing**: Shooting at least three exposures, including the metered exposure and one or more overexposed and underexposed images, to increase the chances of shooting at least one correct exposure.
- **byte:** A unit of computer information or data-storage capacity consisting of a group of eight bits.
- **CCD**: Charge-coupled device, a photocell sensor arranged in densely packed arrays that records light in digital cameras.

CD: Compact disk, an optical digital storage medium with a limit of 600 megabytes.

chromatic aberration: Spurious color generated by lens imperfections seen on sharp edges in a photograph.

clipping: When the dynamic range of the scene exceeds the capacity of the sensor, information at the extremes (for example, very light and/or very dark frequencies) is clipped from the file.

CMOS: Complementary metal oxide semiconductor, a digital camera sensor that uses less energy than other designs, such as CCD.

CMYK: Cyan, magenta, yellow, and key (black), the color space used in the four-color printing industry.

color depth: A synonym for bit depth, the number of bits per pixel. The more bits, the more gradations of color and brightness that can be displayed.

color space: The range of hue, brightness, and saturation of color.

color temperature: The temperature of light, corresponding to the color of a black body at a given temperature on the Kelvin scale.

compression: Compression file systems discard redundant data to reduce storage size and then reconstruct the original file when it is reopened. All compression systems, including JPEG, lose some data during the process.

contrast: The tonal range between the brightest and darkest pixels.

CPU: Central processing unit, the brains of a computer.

cropping: Either the act of cutting out some of the area of an image or the area of a cropped image.

- **depth of field:** The range of an image in focus measured in distance from the camera.
- diffuser: A device to reduce the intensity and harshness of light.

GLOSSARY

- **dpi**: Dots per inch, a measure of resolution referring to digital files and printer output.
- **DVD:** Digital video disk; a DVD can store up to 4.7 gigabytes of digital information, almost eight times as much as a CD.
- **dynamic range**: The range of tones that any device that detects a range of frequencies can distinguish.
- 8-bit: A measure of the number of values (256 for 8-bit) each pixel can have.

exposure compensation: A camera setting that compensates for predominantly bright or predominantly dark scenes that confuse light meters.

f-stop: The aperture setting of a lens.

falloff: A decline in quality or quantity of light.

- fill flash: Flash used to illuminate shadows, usually underexposed one to two stops to look more natural.
- **filter factor:** The amount of underexposure induced by a filter, represented as f-stops.

FireWire: A fast cabling system for transferring files; also called IEEE 1394.

focal length: The length of a lens, measured in millimeters.

- **focus tracking:** Matching focus as a subject moves, either manually or by using servo autofocus.
- **Gaussian blur:** A blur filter in Photoshop that follows a random distribution defined by the mathematician Gauss.
- graduated neutral-density filter: A filter that blocks light from part of a scene without affecting color; abbreviated GND.
- **grain:** Film consists of chemical grains applied to a transparent surface. Generally, the slower the film, the smaller the grains. Fast film with larger grains produces a pointillist effect. Noise is the digital equivalent of film grain.

grayscale: An image composed of 256 gradations of gray between black and white.

histogram: A graph mapping the distribution of tones in an image; found on cameras and in editing programs such as Photoshop.

hue: A synonym for color.

- **hyperfocal distance**: The distance of the nearest object in acceptable focus when the lens is set on infinity. It gives the greatest depth of field for a given f-stop.
- **incident light meter:** A handheld meter that measures light falling on a subject, as opposed to light reflecting from a subject.
- **ISO:** A standard for rating film speed, which roughly correlates to the ISO settings on a digital camera. The acronym for International Standards Organization.
- **JPEG:** The acronym for Joint Photographic Experts Group, a compression file format that reduces file size 10 to 20 times; expressed in a file name as .jpg.
- **Kelvin:** The temperature scale beginning at absolute zero (-459.67° Fahrenheit), using the same increments as the Celsius scale.
- **layer:** A working space in an editing program that can overlay other layers and be merged into a final single image.
- LCD: Liquid crystal display; a type of screen found on digital cameras and computers.

- **lens flare:** A bright spot on an image caused by a light source shining on the front element of the lens and then reflecting and refracting through the other elements of the lens.
- **macro:** A lens that allows for very close focusing; in computer lingo, a set of commands that can be repeated with a minimum of key strokes.
- magic light: Sunlight just after sunrise and just before sunset.
- **magnification factor:** The amount of magnification caused by small sensors in digital cameras, generally ranging between 30 percent and 60 percent.
- marching ants: On a computer screen, moving cursors or lines that delineate an active selection.
- **matrix metering:** An averaging metering system that uses algorithms to compensate for difficult lighting situations such as backlighting.
- megabyte: One million bytes; abbreviated MB.
- **megapixel**: A measure of resolution for digital cameras corresponding to the number of pixels (picture elements) produced by a sensor. Larger numbers correspond to higher resolutions.
- memory card: Storage cards used in digital cameras and other devices.
- **moiré:** A shimmering pattern produced when two geometrically regular patterns (such as parallel lines or halftone screens) are superimposed, especially at an acute angle.
- noise: The digital equivalent of film grain; also called a digital artifact.
- **palette:** Type of menu in Adobe Photoshop; also, a particular range, quality, or use of color.
- panning: Moving a lens to follow a moving object.
- **parallax:** The difference in apparent angle of an object as seen from two different points.
- **Photoshop:** The most popular and most powerful image editing program; an Adobe product.
- **pixel**: Shortened form of "picture element," the smallest component of a digital image.
- **pixelated:** Said of a digital image with noticeable "sawblade" edges where smooth lines should be.
- **platform:** The computer architecture and equipment using a particular operating system, usually PC (Windows) or Mac (Macintosh).
- **plug-in:** Software that works in concert with an editing program to perform specific tasks.
- **polarizer:** A filter commonly used to darken hazy blue skies and cut glare on water and foliage.
- **prosumer:** A marketing term (derived from *professional* and consumer) describing higher-resolution point-and-shoot cameras.
- **RAM:** Random-access memory; computer memory on which data can be both read and written.
- **RAW:** A lossless image format that requires conversion for use in editing programs; though not an acronym, it is usually expressed in all caps in digital photography parlance.

GLOSSARY

- **reflector:** A shiny or light-colored implement used to bounce light onto a subject, which produces a soft light.
- **resolution:** A measure of sharpness and detail in a digital image, corresponding to the number of pixels or lines per inch.
- **RGB:** Red, green, blue; the primary colors used to create all the colors in computer and television monitors.
- saturation: A measure of color purity and intensity.
- **scratch disk:** A portion of a hard drive used as random-access memory when file sizes grow too large for existing RAM.
- **sensor:** A photosensitive device, the first step in converting light to digital information in a digital camera.
- **shutter lag:** The delay between pressing the shutter button and capturing the image; a design compromise found in less-expensive cameras.
- **shutter priority:** An automatic exposure mode that maintains a constant shutter speed while varying aperture as needed.
- **16-bit:** A measure of the number of different values a single pixel can exhibit; in this case, 65,000.
- **SLR:** Single-lens reflex; a camera design employing a mirror that permits the photographer to focus and meter directly through the lens and any filters affixed to it.
- **spot meter:** An in-camera or handheld light-metering system that samples a restricted percentage of the scene.
- **stitching:** Merging several overlapping images into a single picture using tools in a computer imaging program.
- **Sunny 16:** A rule of exposure: for a frontlit subject in full sun, shutter speed should equal ISO at f/16 (for example, for a digital camera set to ISO 100, proper exposure would be 1/125 second at f/16 or equivalent).

thumbnail: A low-resolution, usually small (hence, the term) version of an image.

TIFF: Tagged image file format; a lossless, platform-independent bitmapped file format, often the preferred file format in the design industry.

TTL: Through the lens; refers to metering light directly from the camera.

USB: Universial serial bus; a standardized serial computer interface that allows simplified attachment of peripherals.

vignette: Light falloff near the margins of the frame, often exacerbated by filters.

white balance: The provision in digital cameras and RAW editors for optimizing color balance for a given color temperature.

RESOURCES

BOOKS

About Photoshop

- Evening, Martin. Adobe Photoshop CS for Photographers: Professional Image Editor's Guide to the Creative Use of Photoshop for the Mac and PC. Burlington, MA: Focal Press, 2004.
- Kelby, Scott. The Adobe Photoshop CS Book for Digital Photographers. Berkeley, CA: New Riders, 2003.
- McClelland, Deke. Photoshop CS Bible. Hoboken, NJ: John Wiley & Sons, 2004.

About Photography

- Sammon, Rick. Rick Sammon's Complete Guide to Digital Photography: 107 Lessons on Taking, Making, Editing, Storing, Printing, and Sharing Better Digital Images. New York: W. W. Norton & Company, 2003.
- Shaw, John. John Shaw's Nature Photography Field Guide. Rev. ed. New York, NY: Watson-Guptill, 2000.
- Wolfe, Art, and Martha Hill. *The Art of Photographing Nature*. New York, NY: Three Rivers Press, 1993.

INTERNET SITES

www.adobe.com. Creator of Photoshop, Elements, Acrobat, and Adobe RAW. www.fredmiranda.com. Low-cost Photoshop and Elements plug-ins as

well as exemplary how-to articles.

- www.luminouslandscape.com. Packed with how-to articles on digital photography.
- *www.nikmultimedia.com.* Manufacturer of Photoshop plug-ins, including the deep and powerful Nik Color Efex Pro 2 and a sharpening program.
- *www.outbackphoto.com.* An online compendium of digital photography tips, reviews, and sources.
- *www.photokit.com.* A great sharpening program and a very good selective contrast program.
- www.robgailbraith.com. News, tips, and articles on digital photography.

MAGAZINES

- *Digital PhotoPro (www.digitalphotopro)* is a new publication from Werner Publishing, the publishers of *Outdoor Photographer*. It covers all aspects of outdoor digital photography.
- Photoshop User (www.photoshopuser.com) concentrates on Photoshop, other Adobe products, plug-ins, and imaging hardware. I learned about many Photoshop techniques by studying their articles.

INDEX

aperture 22, 24, 26, 27, 28, 49, 53, 59, 69, 70, 71, 72, 73, 74, 121, 122, 150 aperture priority 71, 79, 125, 151 artifacts 10, 43, 73, 98, 105, 109, 110, 128, 151 autobracketing. See bracketing autofocus 55, 57, 83, 128 average metering. See metering backlighting 11, 29, 30, 31, 69, 144, 149, 150 backpacking 80 black and white 72, 74, 116, 122-124 blurring 24, 26, 133, 144 bracketing 116, 151 camera cleaning. See gear cameras consumer 44, 45-46, 47, 48, 146; prosumer 46, 48; professional SLR 46-47, 48; larger format 47-48 caves 140 CD burners 87 chromatic aberration 49, 63, 64, 114, 151 cities 143 Clone tool 82, 105-106 close-ups 18, 54, 55, 80, 150 color 37-39 color correction 100-104; filters. See filters color management 89-90 color space 64, 89-90 color temperature 33-36, 59, 62, 74, 151; filters. See filters composition 16, 22-27, 98, 137, 140, 143 computer monitor 87-88, 89-90 computers 86-87 cropping 94, 96-98, 120, 127, 151 depth of field 26-27, 28, 49, 52, 53, 54, 59, 69, 71, 116, 119, 121-122, 150, 151, 152 depth-of-field preview button 24, 27 desaturated colors 38 deserts 134-136 digital blending 116 direct light 29, 136, 138 editing. See photo editing

exposure 26, 45, 46, 48, 57, 58, 59, 64, 68–75, 77, 115, 116, 125, 128, 129,

133, 134, 136-137, 138, 140, 144, 145, 150, 151, 154; digital exposure 42,72-74 exposure compensation 57, 72 Eyedropper tool 101, 102, 104, 105 file formats JPEG 60-61, 63, 77, 79, 110, 118, 151, 152; Photoshop 60; TIFF 60, 61, 110, 154; RAW 61-63, 77, 94 file output 110-111 fill flash 116, 148, 152; digital fill flash 118 filters color correction 59, 119; color temperature 118-119; graduated neutral-density 45, 55-56, 58-59, 115-116, 152; polarizer 11, 45, 55, 56-57, 125, 136, 141, 150, 153; warming 33, 55, 59 fisheye lens. See lenses focus tracking 55, 152 forests 140-141, 143 f-stop 24, 26, 27, 28, 52, 69, 70, 71, 79, 121, 122, 152, 154 gear carrying 79-81; protecting 81-82; keeping clean 82-84 graduated neutral-density filter. See filters grayscale 123, 152

hard drives 87

- harmonious colors 38 Healing Brush 82, 105, 106 History Brush 118 homogenous colors 39 horizon, straightening the 98
- hyperfocal distance 27, 28, 121, 122, 152

image storage systems 77–78 in-camera sharpening 75 indirect light 29, 31, 33, 140 ISO 49, 69, 70, 73, 74, 78, 144, 152

JPEG files. See file formats

Kelvin scale 33, 36, 151

layers 65, 102, 114, 115, 117, 118, 123, 128–129, 152 LCD screen 44, 46, 54, 70, 77, 87, 88, 152

lenses fisheye 53; macro 54, 71, 80, 138, 140, 141, 146, 150, 153; normal 50, 54; shift 53, 54, 119, 120; super telephoto 52-53, 59, 60, 79; telephoto 27, 44, 46, 47, 49, 50, 51-52, 81, 98, 122, 137, 138; tilt 53, 54, 119; wideangle 22, 27, 44, 46, 49-50, 53, 80, 117, 119, 122, 124, 126, 136, 138, 149; zoom 24, 45, 48, 53, 80, 81 light 28-36, 40, 56, 57, 59, 68, 70, 72-73, 74, 75, 134, 136, 137, 138, 140, 141, 143, 144, 151; color of 33-36 light meter 45, 46, 47, 57, 68-69, 72 luminosity 109-110 macro lens. See lenses magic light 35, 74, 134, 153 matrix metering. See metering memory card 43, 44, 75, 77, 78, 80, 87, 93, 128, 153 metering 48, 57, 58, 68-69, 71, 137, 151, 153, 154; average 68, 137; matrix 69, 71; spot 58, 68-69 mountains 136-138 night 35 noise 10, 43, 44, 73-74, 109, 116, 124, 128.153 normal lens. See lenses panoramas 124–128 parallax 49, 53, 54, 119-121, 143, 153 Patch tool 106, 108 people 147-150 photo editing 25, 42, 44, 76-77, 93-94, 97-98, 100-110, 122-129 photo editing programs 60–61, 63–65, 88-89, 95, 114, 118, 124, 125, 153 Photoshop 42, 49, 56, 59, 60, 61, 63, 65, 74, 82, 86, 88-89, 93, 98, 100-101, 105, 108-109, 110, 114-115, 118, 122-129, 153 pixels 43, 61, 63, 64, 98, 101, 102-103, 104, 105, 109, 115, 127-128, 129, 151, 152, 153 polarizer. See filters pre-shoot checklist 78-79 printers 88 printing 110-111 prosumer. See cameras RAW files. See file formats RAW editing program. See photo editing programs reflector 29, 33, 141, 153

resize up 98-99 resolution 43-44, 46, 47-48, 49, 63, 64, 79, 80, 88, 98, 109, 110, 124, 147, 154 right-angle finder 54 ruins 143 rule of thirds 17-18, 20, 143 saturation 11, 37, 42, 57, 61, 64, 95, 100, 124, 136, 154 saving 61, 110 scanners 88 selection 108, 114-115 sensors 42, 43, 44, 45, 46, 47, 48, 49, 50, 52, 54, 58, 72-73, 74, 81-82, 140, 151, 154; cleaning of 82-84 sharpening 109-110, 116, 128 shift lens. See lenses showing up 39-40 shutter lag 46, 47, 48, 146, 154 shutter priority 71, 125, 154 shutter speed 24, 25-26, 52-53, 57, 59, 69, 71, 72, 121, 128, 133, 145, 149 sidelight 69 spot metering. See metering star trails 128-129 stitching 80, 124, 125, 154 storage systems. See image storage systems Sunny 16 69-70, 71, 154 sunrise 35 sunset 35 super telephoto lens. See lenses telephoto lens. See lenses Threshold tool 102-104 thumbnails 93 TIFF files. See file formats tilt lens. See lenses tripods 59-60, 125, 128, 138 TTL 46, 47, 48, 154 twilight 35 underexpose 57, 68, 71, 86, 116 USB 77, 87, 154 viewfinder 44, 45, 46, 54, 57, 81, 122 vignetting 49, 53, 64 warming filter. See filters water 132-134 white balance 33, 36, 63, 64, 74-75, 77, 78, 118, 138, 154 wide-angle lens. See lenses wildlife 144-147 work-flow checklist 92

zoom lens. See lenses

ABOUT THE AUTHOR

JAMES MARTIN has written and photographed for Sports Illustrated, Smithsonian, Outside, Backpacker, Climbing, Boys' Life, Ranger Rick, Outdoor Photographer, Blue, Audubon, Rock & Ice, and other publications. He has written many scientific books for children, including Hiding Out: Camouflage in the Wild and Dragons in the Trees with Art Wolfe. Each was recognized as an Outstanding Science Trade Book by the National Science Teacher's Association and was also a Booklist Editor's Choice, ALA Best Book selection, and ALA Notable Book for Children. Dragons in the Trees was named the 1992 Outstanding Nature Book by the John Burroughs Association and was a recommended book for children by the Children's Literature Center of the Library of Congress.

He wrote Masters of Disguise: The Natural History of Chameleons, the first comprehensive book on chameleons in English. He spent ten years photographing for his books on the mountains of the West, which include *The North Cascades Crest, Mount Rainier,* and *Sierra. Extreme Alpinism,* written and photographed with Mark Twight, covers techniques for climbing and surviving the most difficult mountains. Getty Images represents his photography.

His travels have led him to Africa, Madagascar, Antarctica, Europe, Borneo, Indonesia, and southeast Asia, sometimes as a trip leader for Joseph Van Os Photo Safaris. Over the last three decades he has hiked thousands of miles and climbed extensively.

James Martin and friend, Southern Borneo

OTHER TITLES YOU MIGHT ENJOY FROM THE MOUNTAINEERS BOOKS

Photography Outdoors: A Field Guide for Travel & Adventure Photographers, *Mark Gardner & Art Wolfe* Whether you're a novice or seasoned pro, this guide will help

you capture great outdoor images on film.

The High Himalaya, Art Wolfe and Peter Potterfield An intimate, breathtaking excursion into the world's highest society. A true coffee-table masterpiece.

1

Arctic National Wildlife Refuge: Seasons of Life and Land Subhankar Banerjee

> IFARW 778 .71 M381

A collect premier

MARTIN, JAMES DIGITAL PHOTOGRAPHY OUTDOORS CENTRAL LIBRARY 01/07

that whome corridors make good sense.

Arctic Wings: Birds of the Arctic National Wildlife Refuge

Manomet Center for Conservation Science Some of the best avian photographers capture the

Some of the best avian photographers capture the vibrancy of the world's most important nesting ground.

ALSO FROM THE AUTHOR Extreme Alpinism: Climbing Light, High Mark Twight & James This master class ce: with little gear and t

۲۲ M Mountaineers Books has more 500 outdoor recreation titles i Receive a free catalog at www.mountaineersbooks.org. rove

THE MOUNTAINEERS. founded in 1906, is a nonprofit outdoor activity and conservation club, whose mission is "to explore, study, preserve, and enjoy the natural beauty of the outdoors. . . . " Based in Seattle. Washington, the club is now the third-largest such organization in the United States, with seven branches throughout Washington State.

The Mountaineers sponsors both classes and year-round outdoor activities in the Pacific Northwest, which include hiking, mountain climbing, ski-touring, snowshoeing, bicycling, camping, kayaking, nature study. sailing. and adventure travel. The club's conservation division supports environmental causes through educational activities, sponsoring legislation, and presenting informational programs.

All club activities are led by skilled, experienced instructors who are dedicated to promoting safe and responsible enjoyment and preservation of the outdoors.

If you would like to participate in these organized outdoor activities or the club's programs, consider a membership in The Mountaineers. For information and an application, write or call The Mountaineers, Club Headquarters, 300 Third Avenue West, Seattle, WA 98119; (206) 284-6310. You can also visit the club's website at www.mountaineers.org or contact The Mountaineers via email at clubmail@mountaineers.org.

The Mountaineers Books, an active, nonprofit publishing program of the club, produces guidebooks, instructional texts, historical works, natural history guides, and works on environmental conservation. All books produced by The Mountaineers Books fulfill the club's mission.

Send or call for our catalog of more than 500 outdoor titles:

The Mountaineers Books 1001 SW Klickitat Way, Suite 201 Seattle, WA 98134 (800) 553-4453 mbooks@mountaineersbooks.org

www.mountaineersbooks.org

The Mountaineers Books is proud to be a corporate sponsor of The Leave No Trace Center for Outdoor Ethics, whose mission is to promote and inspire responsible outdoor recreation through education, research, and partnerships. The Leave No Trace program is focused

specifically on human-powered (nonmotorized) recreation.

Leave No Trace strives to educate visitors about the nature of their recreational impacts, as well as offer techniques to prevent and minimize such impacts. Leave No Trace is best understood as an educational and ethical program, not as a set of rules and regulations.

For more information, visit www.LNT.org, or call (800) 332-4100.